THE RIVER SHANNON

Ireland's Majestic Waterway

CARSTEN KRIEGER

THE O'BRIEN PRESS
DUBLIN

CARSTEN KRIEGER is a professional photographer based in the west of Ireland. His unique images are highly acclaimed and over the past decade he has become one of Ireland's foremost photographers covering various topics from landscape and nature to architecture and food photography.

He has published numerous books on Ireland's landscape, wildlife and heritage including *Ireland's Ancient East*, *Ireland's Coast* and the popular *Ireland's Wild Atlantic Way* and regularly works for Fáilte Ireland, The UNESCO Burren and Cliffs of Moher Geopark and other clients.

.

First published 2018 by
The O'Brien Press Ltd,
12 Terenure Road East, Rathgar,
Dublin 6, Ireland.
Tel: +353 1 4923333; Fax: +353 1 4922777
E-mail: books@obrien.ie.
Website: www.obrien.ie
ISBN: 978-1-84717-908-1
The O'Brien Press is a member of Publishing Ireland.
Text & photography © copyright Carsten Krieger, 2017
Copyright for typesetting, layout, editing, design
© The O'Brien Press Ltd
Credits: Photographs p43 © Derek Spiers; photograph p147 ©
Foynes Flying Boat & Maritime Museum
Maps by www.redrattledesign.com

Printed and bound in Drukarnia Skleniarz, Poland.
The paper in this book is produced using pulp from managed forests.

Published in

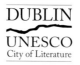

DUBLIN
UNESCO
City of Literature

CONTENTS

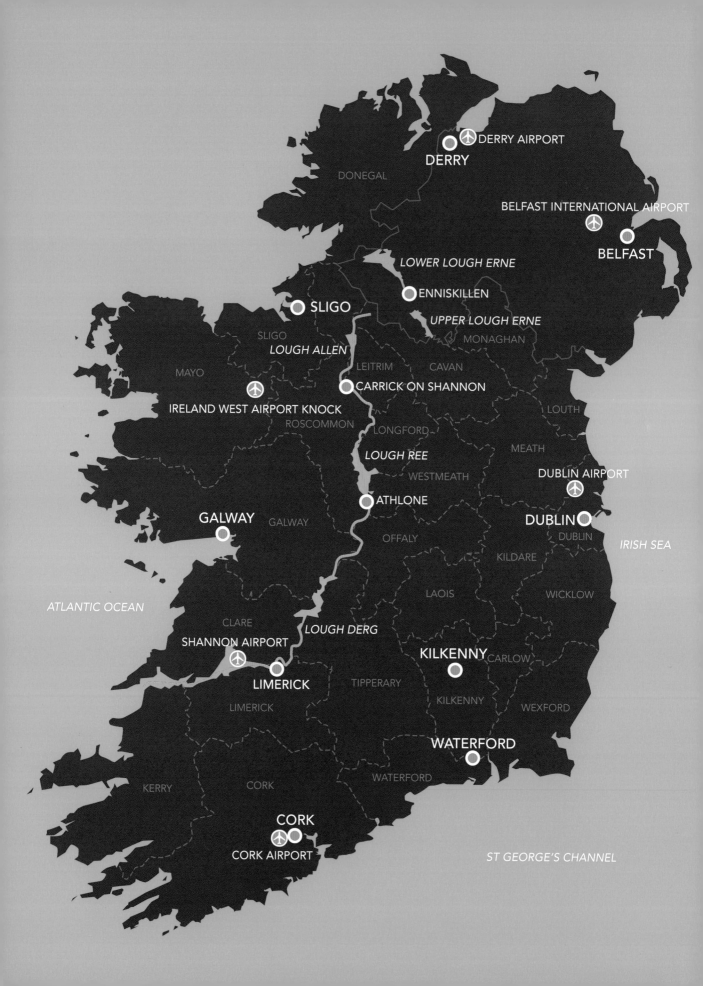

THE SHANNON
AND LAKELANDS

The centre of Ireland is a gentle and timeless country. At its heart flows the Shannon, Ireland's longest river, which runs for over 360km from its source at the Cavan-Fermanagh border to its mouth between Kerry Head and Loop Head. It is said the river was named after Sionnan, a granddaughter of Lir, who like others before her sought wisdom by catching and eating the legendary Salmon of Knowledge who resided at Connla's Well. Sionnan, despite many warnings against doing so, caught the fish and roasted it on a fire beside the well. But as soon as she took the first bite, the well rose up, bursting and sweeping Sionnan away in what would become Ireland's mightiest river.

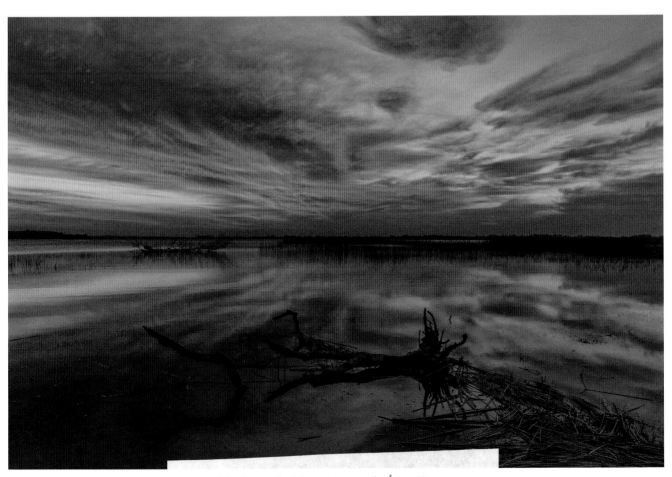

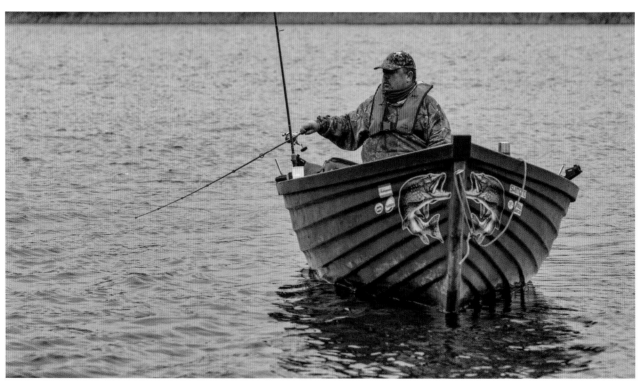

The Shannon has always been a major waterway as well as a physical border, dividing Ireland's west from its east. Gerard Boate described the river in 1645 in *A Natural History of Ireland*:

> *The principallest of all is the Shannon, who taking his original out of Lough Allen, and in his course dividing the province of Connaught from Leinster, and afterwards also from Munster, passeth through two other great loughs, to wit, Lough Ree, whereout she cometh just above Athlone (a mean market town, but adorned with a stately and strong castle, the ordinary residence of the presidents of Connaught) and Lough Dergh, about halfway betwixt Athlone and Limerick, and a little below the said town she dischargeth herself again into another lough, by far the biggest of all, the which extending itself from Limerick unto the sea, and above fifty miles long, it is held by the Irish as well as the English not for a lough, but for the Shannon itself, and consequently called with that name.*

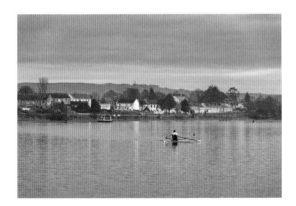

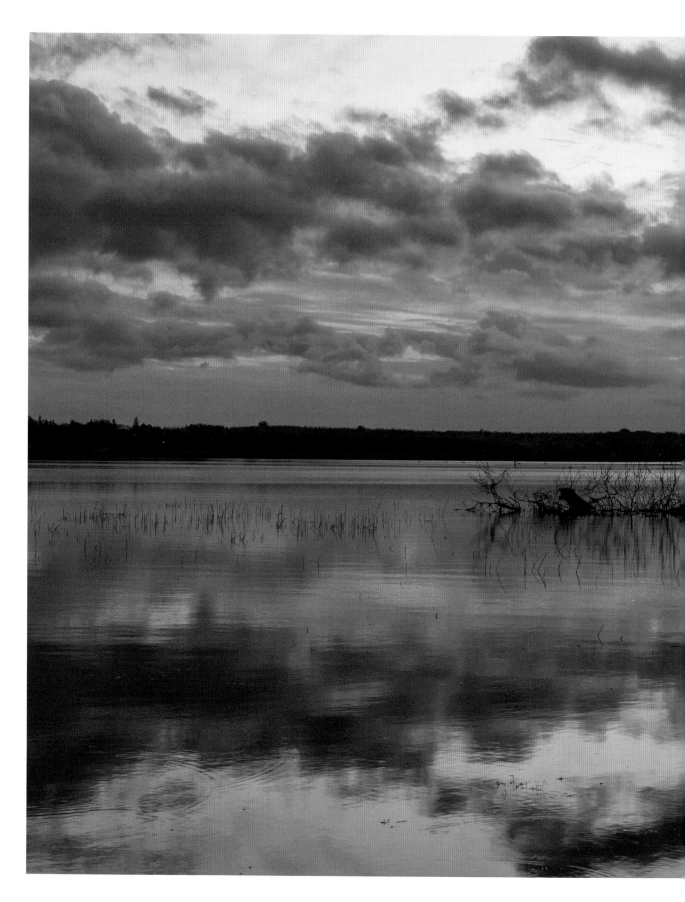

Close to the Shannon's source lie the vast lakelands of Fermanagh and Cavan, which are mainly formed by the river Erne. The first proper connection between the Erne and the Shannon opened as the Ballinamore-Ballyconnell Canal in 1846, but closed again after only nine years. More than a hundred years later plans were made to reclaim the canal and in 1994 the Erne was officially re-connected to the Shannon via what is now known as the Shannon-Erne-Waterway.

To the south, further pockets of lakes can be found on both sides of the Shannon: Lough Key, Lough Arrow, Lough Gara and others to the west of Carrick-on-Shannon; east of Lough Ree lie Lough Sheelin, Lough Owel and Lough Ennell (to name a but few) and even further south the eastern half of Co. Clare hosts a string of lakes including Doon Lough, Lough Bridget and Lough Graney.

Though this part of Ireland is mainly used for recreational fishing and pleasure boating, it also plays a major part in energy production. The Shannon hosts four power stations: two, located in Lanesborough and Shannonbridge, are peat-fired; Moneypoint at the Shannon Estuary uses coal and Ardnacrusha at the Clare-Limerick border draws its power directly from the Shannon.

West of Limerick City the Shannon opens up into an estuary and the surrounding landscape starts to change considerably. The gentle fields and meadows give way to muddy and rocky shores that eventually rise into vertical cliffs where the Shannon meets the Atlantic Ocean.

After producing my books *Ireland's Wild Atlantic Way* and *Ireland's Ancient East* I was eager to explore this often forgotten and undervalued part of Ireland. One reason was simple curiosity: I have been living at the Shannon Estuary for many years. Kilbaha Bay, the last sheltered haven before the Shannon becomes the Atlantic Ocean, is just down the road and I thought it might be interesting to see where all this water originates.

Some places I had visited before: Lough Derg, Clonmacnoise and the Upper and Lower Lough Erne were not unfamiliar to me, but those better-known places are just a very small part of a bigger picture. Over the period of sixteen months or so I travelled up and down the Shannon and took more than a few detours to the lakes along the way. What happened during this time was that I fell utterly in love with the place. Autumn colours at Portumna

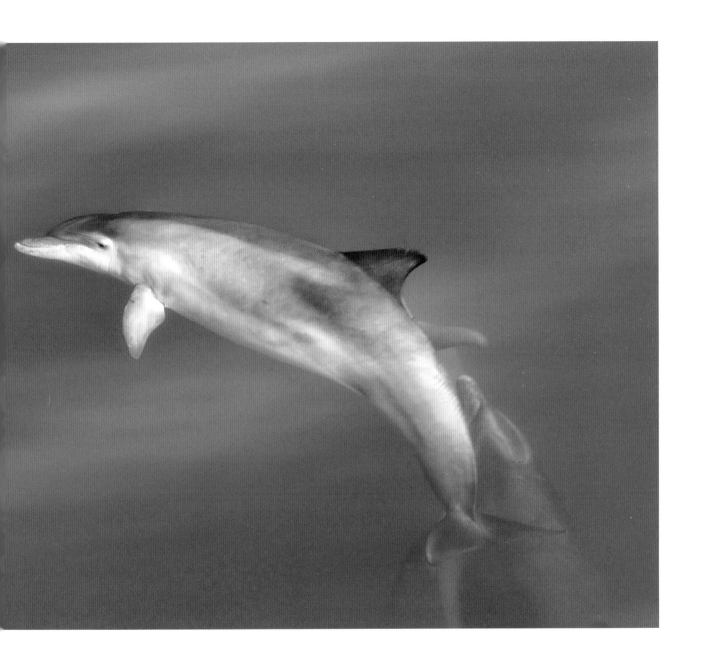

Forest Park, spring flowers at the banks of the Shannon, Lough Ree sunsets and the many tranquil harbours put their spell on me.

The Shannon and the Lakelands lead something of a Jekyll and Hyde existence. In the short summer months the waterways, towns and villages seem to explode with activity. Boats and cruisers are jetting up and down the Shannon, fishermen and families enjoy the banks of rivers and lakes and the towns and villages bustle with festivals and events. If you would return only a few weeks later all you would find are empty marinas and towns that barely show signs of life. I remember my first prolonged stay in Shannonbridge in early March. The town felt completely abandoned and standing in the centre of town at noon felt like being in one of those old Western movies. The only difference was that instead of tumbleweed, Tayto packs were blown down the main road.

This was one of those projects I didn't want to end. There is so much to discover and to really see all of the Shannon and the Lakelands, its landscape, people, heritage and wildlife, could keep one busy for a lifetime.

Carsten Krieger

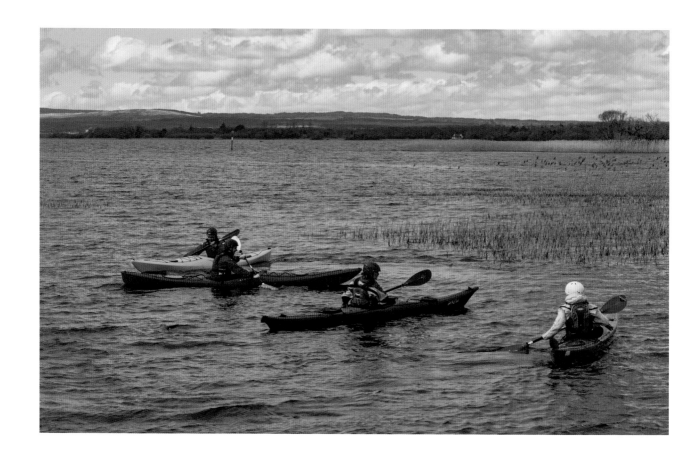

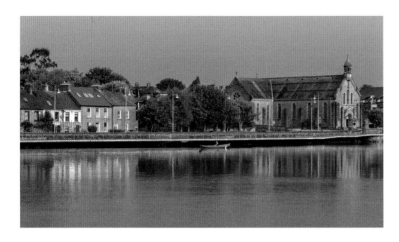

Photography Notes

This book was almost entirely made with a new kind of camera. In the early days of scenic photography big and heavy large-format cameras were the tool of choice for most photographers. Then digital capture slowly took over from film-based photography, but until recently no digital sensor was able to capture as much detail as large-format film. A few years ago mirrorless camera systems arrived on the scene and along with them new breeds of sensors that come very close to rivalling large-format film, with the additional advantage of being able to capture a wide dynamic range. The Sony 7R II is a camera that comes with 42MP, is very small and light, can be used with almost any lens ever made (by using an adapter) and has a dynamic range that makes the use of graduated filters obsolete.

The majority of images in this book were made with this camera together with adapted Canon TS-E lenses and native Sony lenses. The aerial images were made with a DJI Phantom 4 Pro.

Acknowledgements:

Putting together a book like this doesn't work without the help and support from others. As always I would like to thank my family for putting up with my work and the team at The O'Brien Press for providing me with the opportunity to continue making books.

I would like to send a huge thank you to the Arigna Mining Experience, Marble Arch Caves, Belvedere House & Gardens, ESB at Ardnacrusha and Moneypoint Power Stations, Foynes Port Company, Carmen's Riding School, St. Michael's Rowing Club and the folks at Killaloe Farmer's Market.

A very a special thank you goes to Mike Kiely, fisherman and model; Timmy Donovan of Sean's Pub; Jonathan of Nua Canoe; Helen Conneely of Celtic Roots Studio.

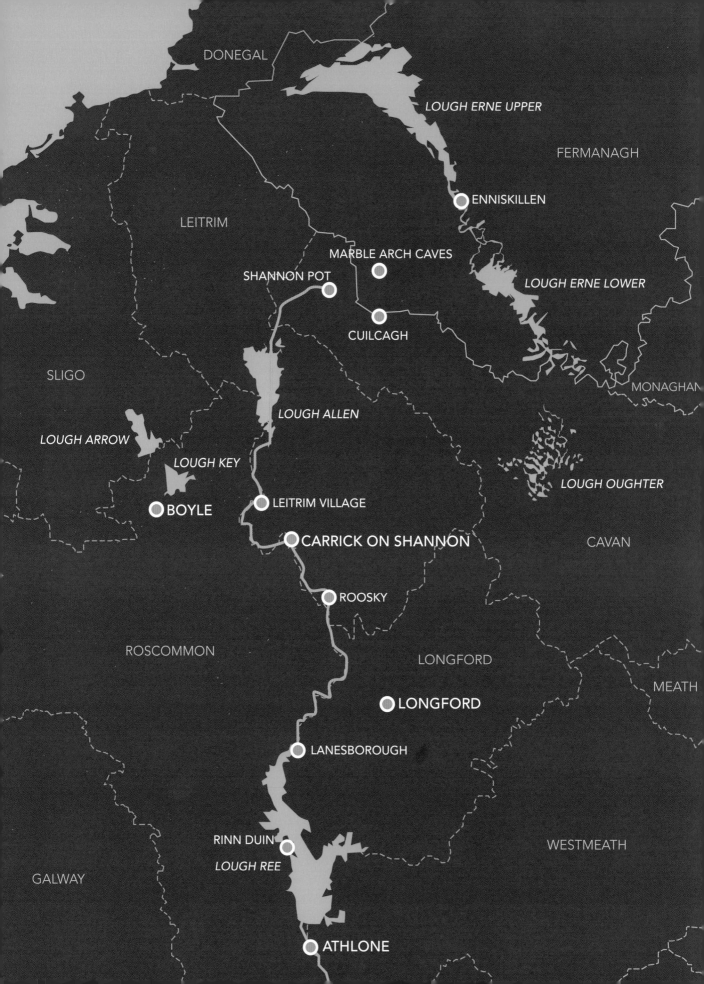

CHAPTER 1:

FROM THE SHANNON POT TO LOUGH REE

The Shannon starts its journey at the foot of the Cuilcagh Mountains from a small pool known as the Shannon Pot. This small, deep body of water, fed from underground caverns and caves and nestled in the quiet countryside at the foot of the Cuilcagh Mountains on the Cavan-Fermanagh border, is the traditional source of Ireland's longest river.

On the other side of the Cuilcagh Mountains are the Upper and Lower Lough Macnean, part of the extensive lakelands that cover Co. Fermanagh, Co. Cavan and parts of Co. Monaghan and Co. Leitrim.

The juvenile Shannon runs to the east of these lakelands and has grown into a proper river by the time it enters the first of the three major lakes along its course, Lough Allen. At the southern end of the lake the Lough Allen Canal exits the lake at Drumshanbo, while the Shannon itself leaves the lake a bit further north at Bellantra Bridge. The canal and the river join forces again a bit further south at Battlebridge and from there the Shannon makes its way towards the town of Carrick-on-Shannon, one of the major harbours on the Shannon. At this stage the river runs through a wondrous water world: Lough Key, Lough Arrow and others are to the west; the intrinsic Lough Oughter and numerous smaller lakes lie to the east.

South of Carrick-on-Shannon the river itself turns into a lakeland: the Shannon opens up into a string of larger waterbodies like Lough Corry, Lough Boderg and Lough Forbes before it enters Lough Ree, the second largest lake along its course, at Lanesborough.

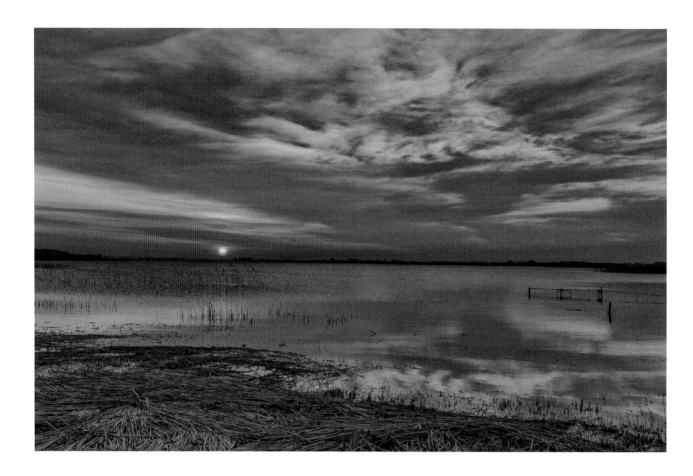

Above: Lough Ree Sunset, Co. Westmeath

Opposite top: Cloondara, Co. Longford

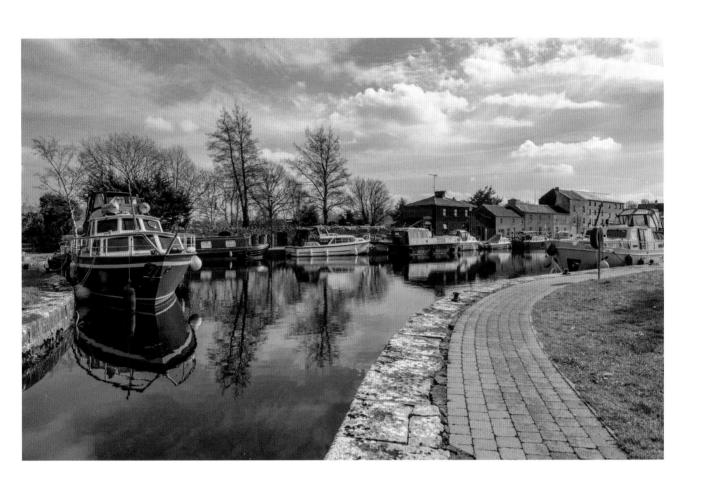

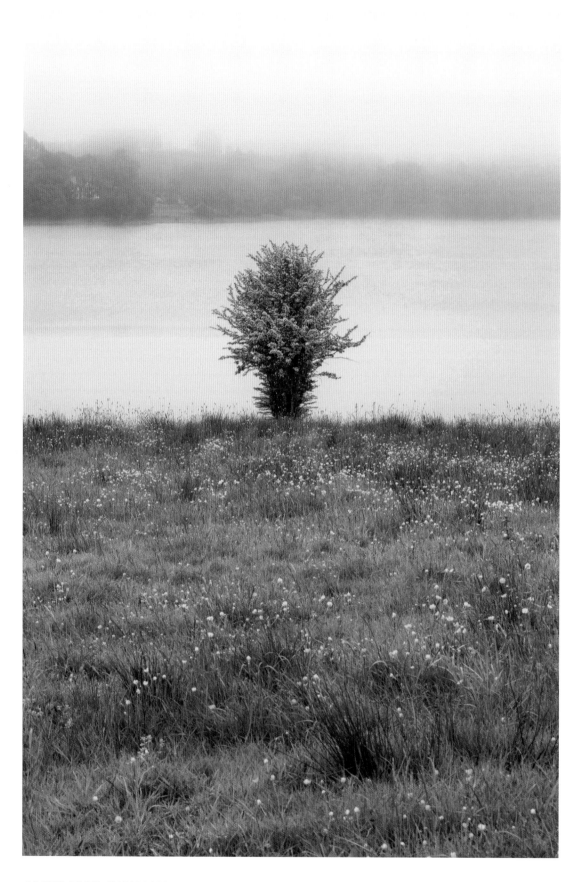

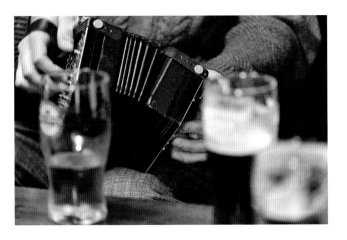

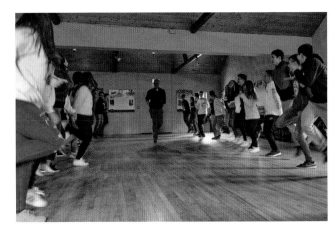

Opposite: Lough Oughter, Co. Cavan

Above left: Pub Session, Carrick-on-Shannon, Co. Leitrim

Above right: Irish Dancing class, Dún Na Sí Heritage Park, Moate, Co. Westmeath

Bottom: Kayak on Lough Allen

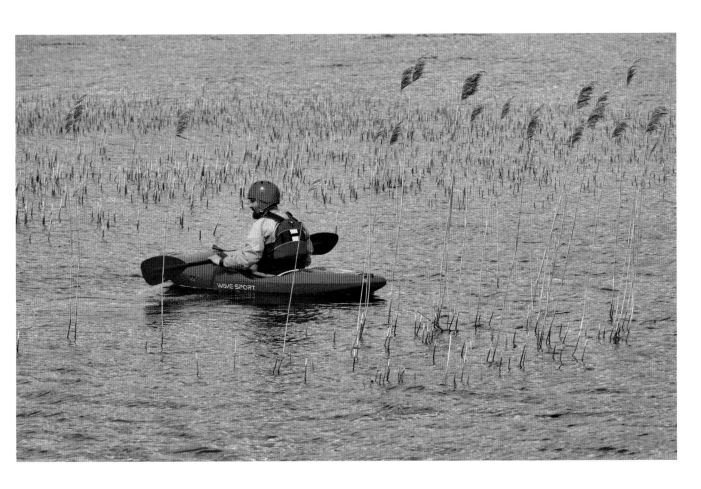

... the source of which is by tradition assigned not to the origin of the Owenmore as one might expect, but to a round pool on a short feeder of the same, the pool being known as Lugnashinna or the Shannon Pot.

Robert L. Praeger, from 'The way that I went', 1937

Below: The Shannon Pot, Co. Cavan
Opposite: Molly Mountain, Marble Arch, Co. Fermanagh

If you want an unusual experience try cave-lake swimming. The water is cold and as black as ink, the candle stuck in your hat is inclined to be extinguished if the roof gets low or if owing to a blunder your head goes under...

Robert L. Praeger, from 'The way that I went', 1937

The Marble Arch Caves are formed by three rivers that have their origin on the northern slopes of the Cuilcagh Mountains. The rivers emerge on the surface, but soon disappear below the lime-stone. Eventually these three streams meet underground to form the Cladagh River at the heart of the Marble Arch Caves. The caves were first explored in 1895 by French cave explorer Edouard Alfred Martel and the Dublin-born scientist Lyster Jameson. This first journey into the unknown was made by candlelight in a collapsible canvas canoe. After several hours Jameson and Martel, who was considered to be the world's foremost cave explorer at the time, emerged exhilarated from what can only be described as a strangely beautiful wonderland of stalactites, veils and cascades of calcite (some of which have been growing for 50,000 years), mirror-like pools and sandy beaches that have never seen daylight.

In 1985 the caves were developed into a show cave and opened to the public. In 1998 the Cuilcagh Mountain Park was opened at the northern slopes of the Cuilcagh Mountains and in 2015 the whole area became a designated UNESCO Global Geopark.

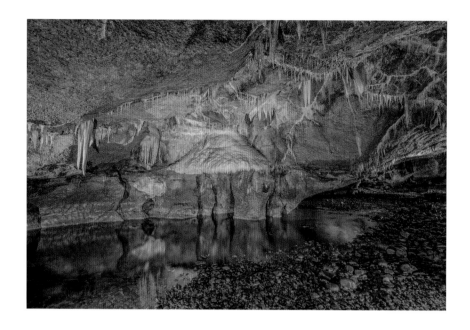
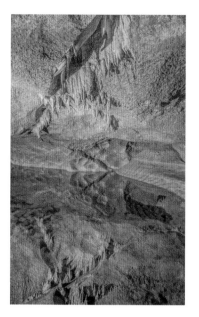
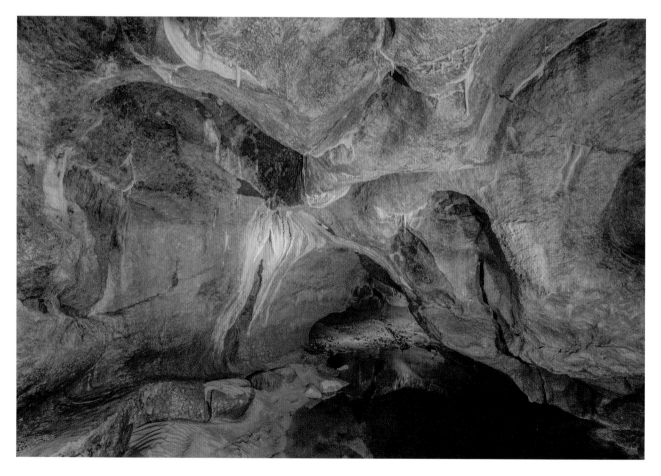

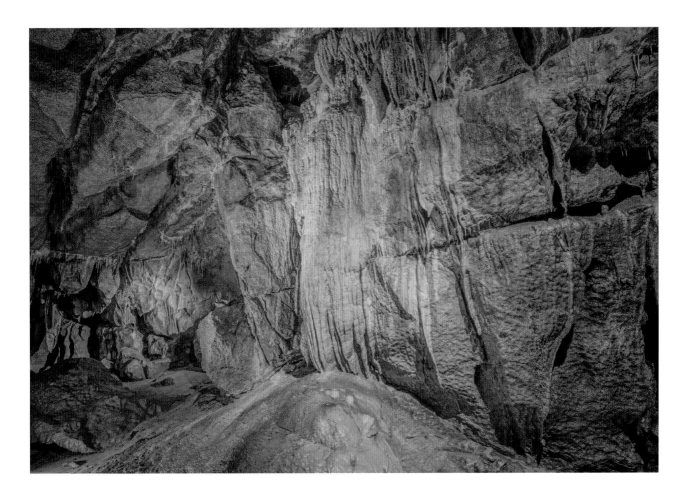

Opposite and above: Marble Arch Caves, Co. Fermanagh

The Lakelands are an intricate maze of land and water. The biggest of the lakes are formed by the river Erne. The Lower Lough Erne is a vast expanse of water dotted with numerous islands. The Upper Lough Erne, Lough Oughter and Lough Gowna are formed by the twisting, turning and branching of the River Erne, forming numerous peninsulas and countless islands connected by narrow channels.

The Lakelands continue to the east of the Erne Complex all the way to Lough Allen and the River Shannon.

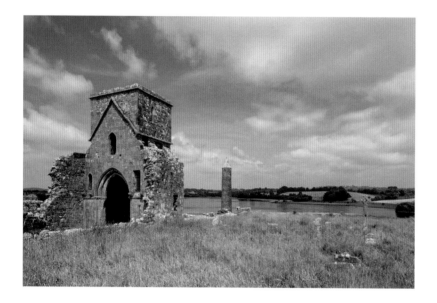

Left: Devenish Island, Lower Lough Erne, Co. Fermanagh
Below: White Island, Lower Lough Erne, Co. Fermanagh
Opposite: White Island, Lower Lough Erne, Co. Fermanagh

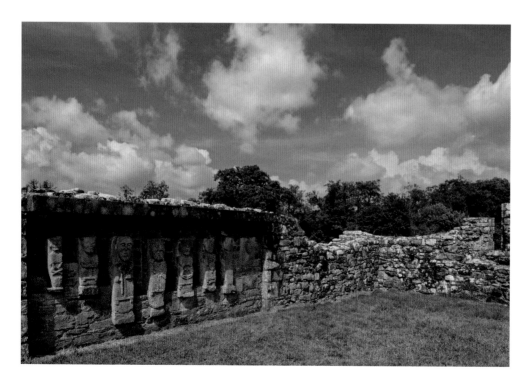

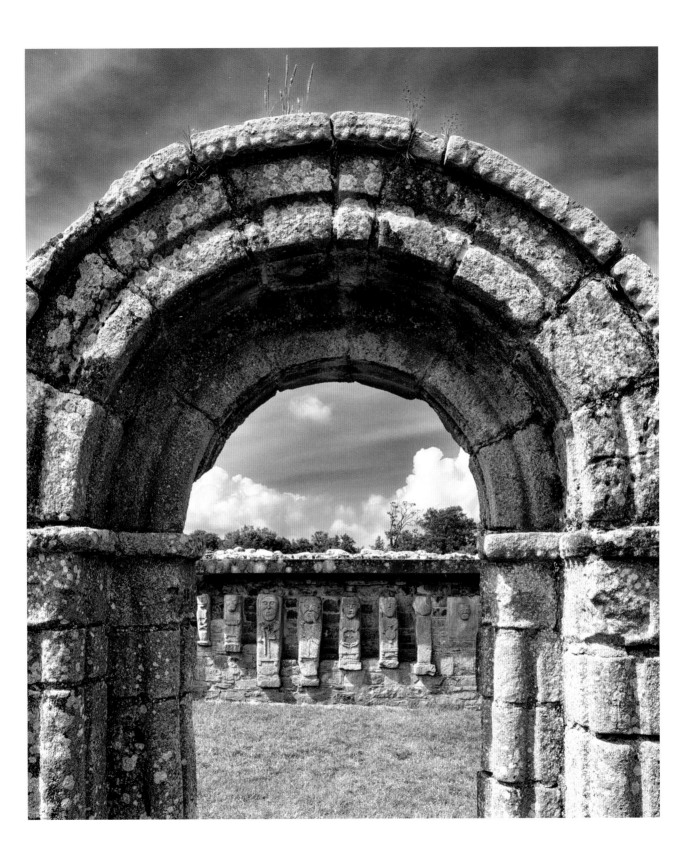

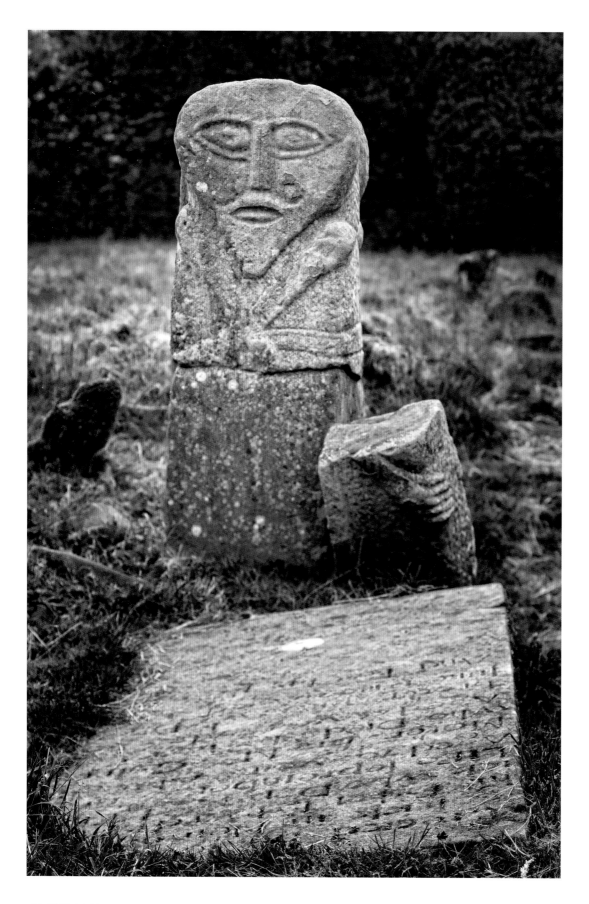

Opposite: Janus Figure, Lower
Lough Erne, Co. Fermanagh
Right: Camagh Bay, Lower
Lough Erne, Co. Fermanagh

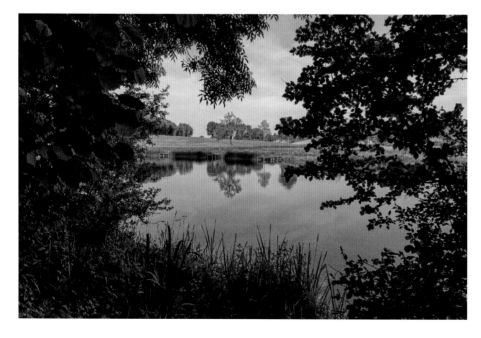

Above: Crom Estate, Upper Lough Erne, Co. Fermanagh

Left: Cloonatrig, Upper Lough Erne, Co. Fermanagh

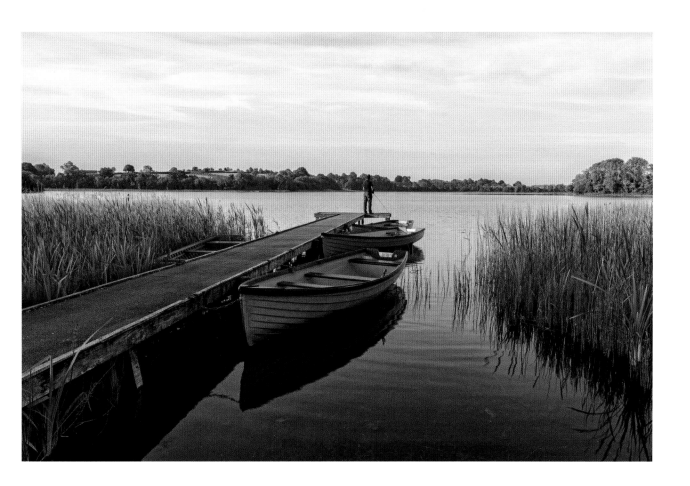

Above: Fisherman, Upper Lough Erne, Co. Fermanagh
Right: Crom Church, Upper Lough Erne, Co. Fermanagh

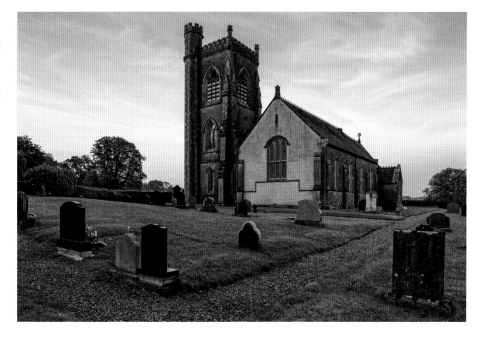

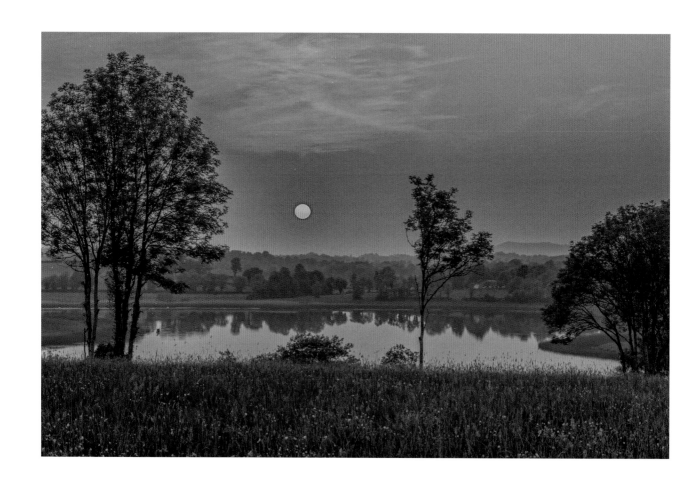

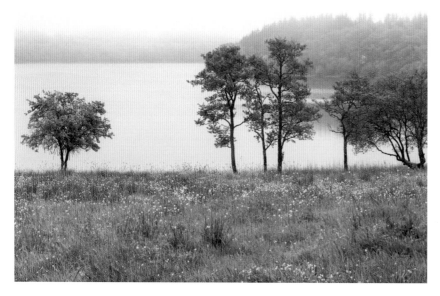

Above: Summer Sunset, Upper Lough Erne, Co. Fermanagh
Left: Foggy Morning, Lough Oughter, Co. Cavan

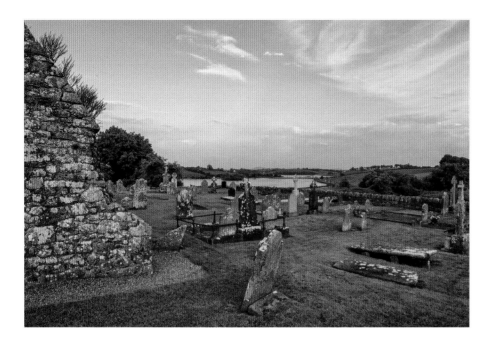

Left: Drumlane Abbey, Lough Oughter, Co. Cavan
Below: Brackley Lough, Co. Cavan

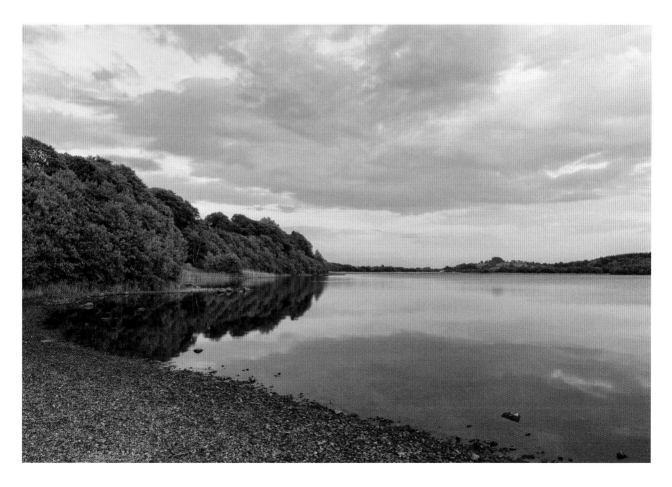

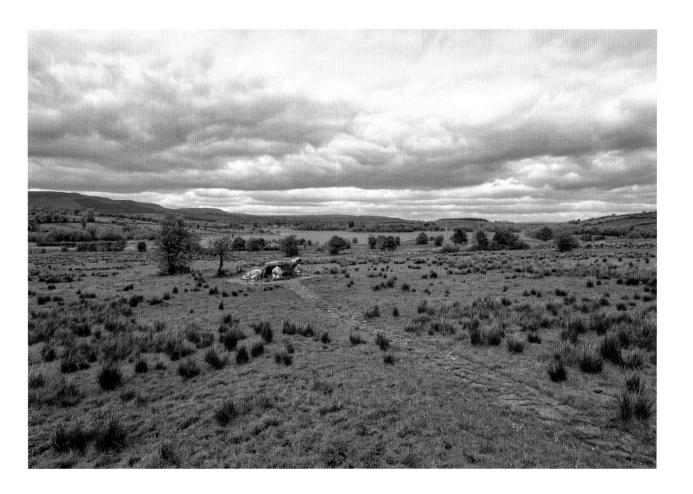

Opposite: Old Cottage Window, Co. Cavan
Above: Lough Scur and Megalithic Tomb, Co. Leitrim
Right: St John's Lough, Co. Leitrim

The town of Enniskillen is located on an island between the Upper and Lower Lough Erne and grew around the castle which was built in the sixteenth century. The town's name comes from the Irish *Inis Ceithleann*, meaning 'Ceithlen's island'. Ceithlen or Cethlenn is a figure from Irish mythology who was wounded in battle. Trying to escape her enemies she attempted to swim across the river Erne, but never made it to the other side and died from her wounds on the island that now carries her name.

During the Troubles (the Northern Ireland conflict that lasted from 1968-1998) Enniskillen regularly made headlines for all the wrong reasons. From 1972 onwards hardly a year passed without a deadly attack in the town. The worst of those happened on 8 November 1987 when eleven people were killed by an IRA bomb during Remembrance Day celebrations.

Today Enniskillen is a peaceful and bustling town, a lively hub of activity in the centre of the Irish Lakelands.

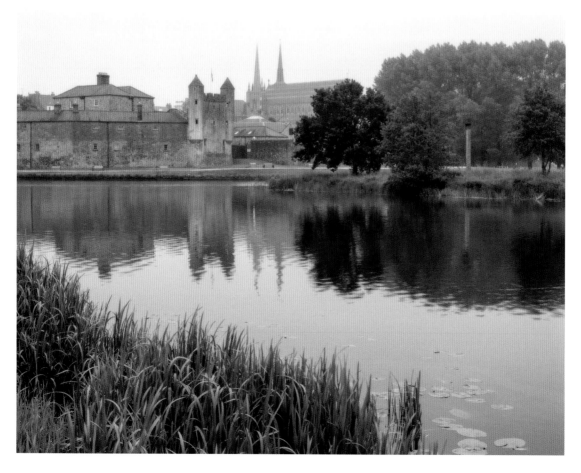

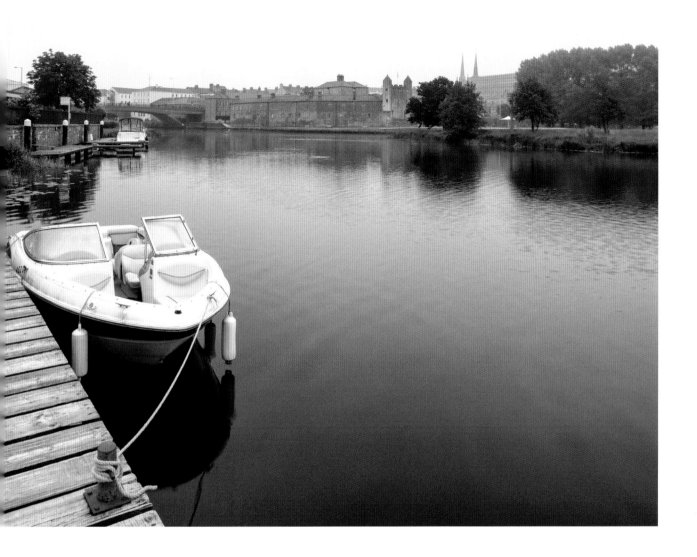

Opposite: Enniskillen Castle, Co. Fermanagh

Above: Enniskillen, Co. Fermanagh

One day a women went down to a holy well to wash her clothes as she did every week. She was just about to finish when a calf suddenly jumped out of the well. The poor woman got the fright of her life, jumped up and run away as fast as she could. The calf ran after her, scaring the woman even more. In addition the well begun to overflow, sending gushes of water after the pair. In her panic the woman stumbled and fell over three times. The rising water went around those spots creating islands in the newly forming lake. When the woman fell over for a fourth time she couldn't find the strength to get up again and drowned. The name of the lake is Lough Gowna, the Lake of the Calf.

Below: Lough Gowna, Co. Cavan
Opposite: Woodland near Lough Sheelin, Co. Cavan

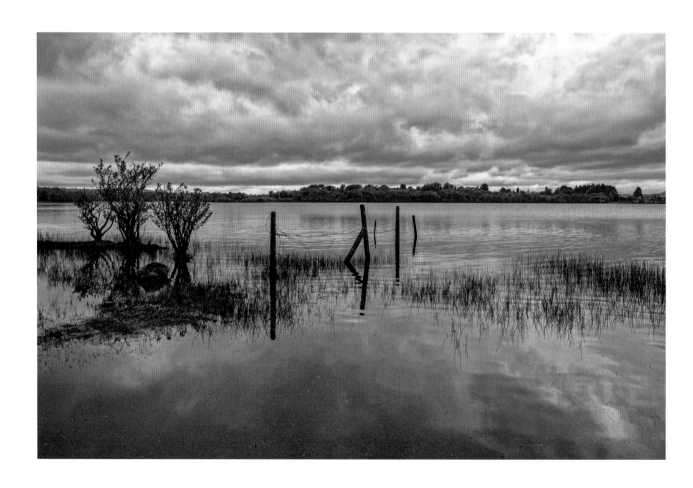

Today Lough Sheelin is a tranquil place, but some three hundred years ago it was the home of a *Dobharchú*, a fearsome cross between a hound and an otter. Back then the McLoughlins lived close to the lake and one afternoon the lady of the house went down to the lake to wash clothes. As she hadn't returned home when the sun started to go down her concerned husband went looking for her. When he reached the lakeshore he saw the lifeless body of his wife, covered in blood with a strange animal lying on top.

Filled with terror and grief he drew his sword and sliced the head off the creature. The dying animal let out a bone-chilling cry and immediately the waters of the lake begun to boil and another creature emerged from the water and threw itself at the man. McLoughlin turned and ran for his horse, the *Dobharchú* in close pursuit. The chase lasted a good while, all the way into Co. Leitrim. When McLoughlin and his horse galloped into a graveyard they tripped over a massive headstone. At the same time the beast made a leap and the headstone fell right on top of it and crushed its skull.

McLoughlin decided to put his wife to rest in this very graveyard and her headstone can still be seen today.

The Ballinamore-Ballyconnell Canal was built between 1846 and 1860 to link the River Erne to the Shannon. Unfortunately the timing for the canal was bad; by the time it was completed the railway had become the preferred method to transport goods and the canal was closed after only nine years of operation. During this time only eight boats had used the Ballinamore-Ballyconnell Canal.

In 1994 the canal received a new breath of life and reopened as the Shannon-Erne Waterway; cruisers and barges are now a regular sight.

Lough Allen is the smallest of the three main Shannon lakes and is shared by Co. Leitrim and Co. Roscommon. It is shaped like an upside down isosceles triangle and is guarded by Sliabh an Iarainn to the east and the Arigna Mountains on its western side.

Where the Shannon exits the lake, sluice gates were installed in the 1920s as part of the Shannon Hydroelectric Scheme. In the early years of the scheme, Lough Allen was used as a reservoir to guarantee continued water flow for the power station at Ardnacrusha further south. However, this being Ireland extreme drought is a rare thing and the Lough Allen reservoir has been put to use very rarely. On one occasion, however, the water levels of the lake dropped to an all-time low to reveal sandy beaches and remains of an extensive oak forest. In addition, a vast number of artefacts from different time periods were discovered along the lake, which gave rise to the theory that the water levels of the lake had been much lower in the past and the land more suitable for agriculture than it is today. A description of the area from the seventeeth century supports this theory:

The land is mountainous in many places, they are wooded and course. The soil wet and deep but very fertile abounding in all its lowlands with good green grass. The chief product is black cattle, where it is well stored. In a few places very good rye, wheat, barley, oats and peas are grown.

There are very good woods of ash, oak, alder, birch, whereof a great part is consumed by several ironworks around the region.

Tadhg O Rourke, 1680

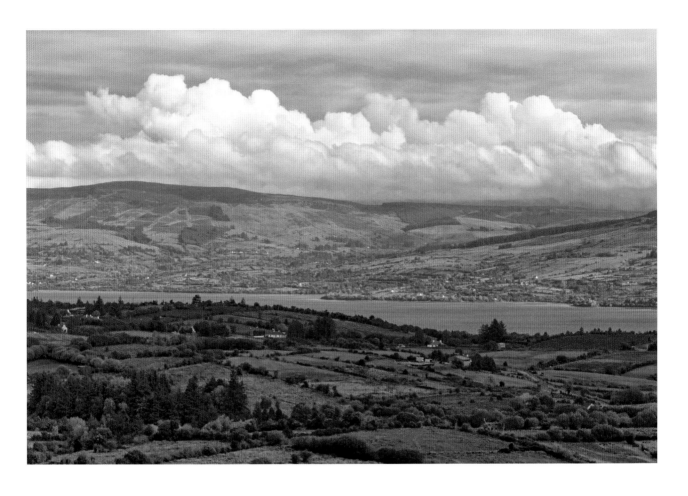

Above: Lough Allen seen from the Arigna Mountains, Co. Leitrim

Below: Carmongan Pier, Lough Allen, Co. Leitrim

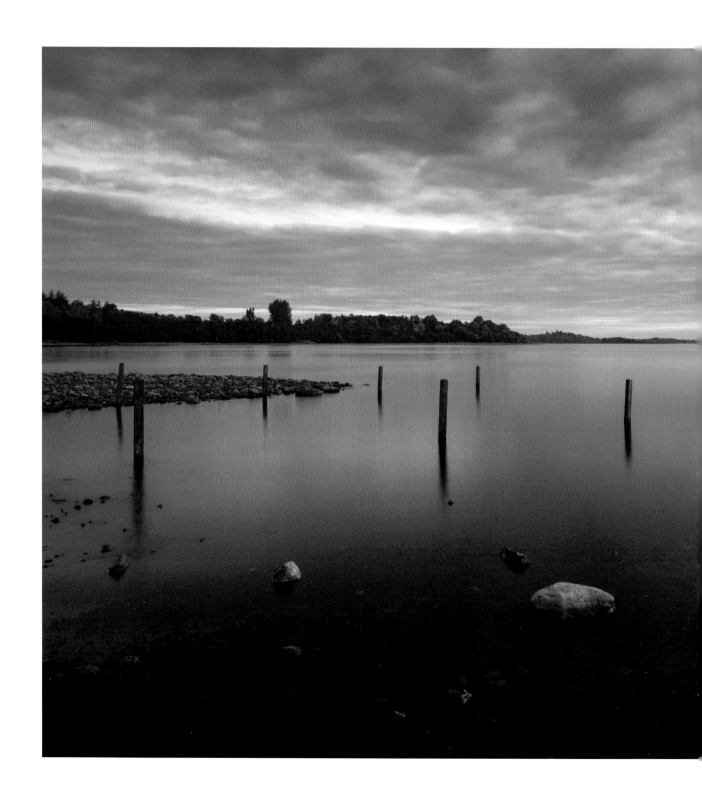

Top: Barge leaving Spencer Harbour, Lough Allen, Co. Leitrim **Middle:** Spencer Harbour, Lough Allen, Co. Leitrim **Bottom:** Spencer Harbour Brick Works, Lough Allen, Co. Leitrim

In the late eighteenth century coal was discovered in the Arigna Mountains and the mines soon became the major employer in the area. From a spacious main tunnel slopes extended on either side. The slopes were connected by branches which were driven into the rock every 9 metres. The coal seams at Arigna were very narrow, which resulted in very cramped working conditions. The miners had to squeeze into a space no higher than 50cm and remove the coal with a short-handle pick and shovel. In the 1940s the handle pick was replaced by an air pick and a coal cutting machine, known as Iron Man. The coal was then loaded onto a hutch, a small wagon, and brought through the branches, slopes and main tunnel back to the weighing point.

The work was back breaking, and in addition to the narrow spaces the miners had to tolerate high levels of noise and coal dust as well as the threat of serious injury. Many youngsters left school at the age of fourteen to start their mining careers.

Miners had to provide their own clothes, helmets and tools. Lunch (bread, butter and sweet tea, preferably cold) was eaten in the mine and light was provided by candles and later carbide lamps. Battery lamps were only being used in the last fourteen years before the Arigna Mines closed in 1990.

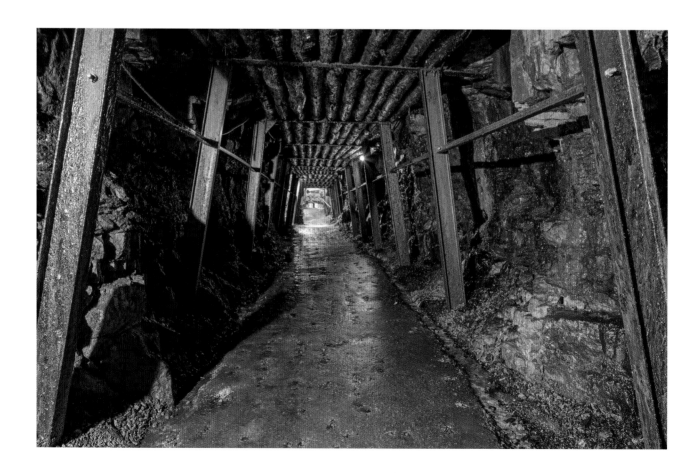

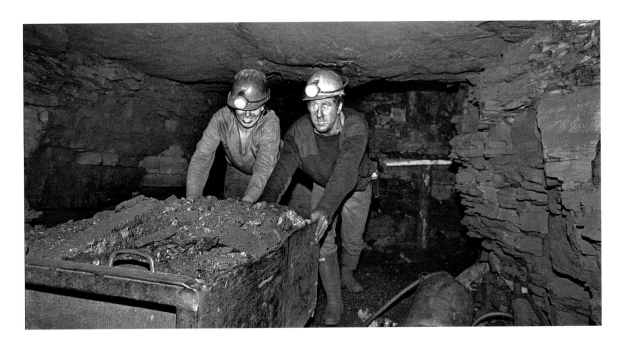

Opposite: Arigna Mines, Main Tunnel, Co. Leitrim

Below left and above: Arigna Miners (miner photographs copyright Derek Spiers)

Below right: Arigna Mines Tools, Co. Leitrim

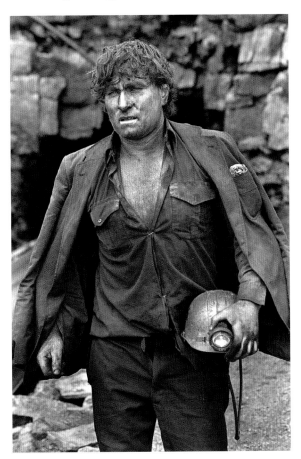

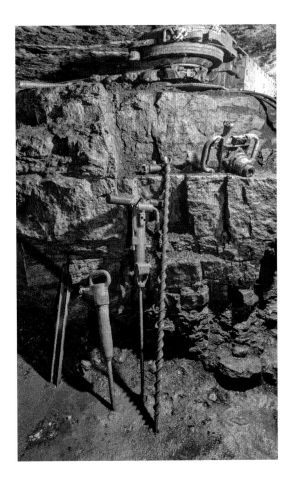

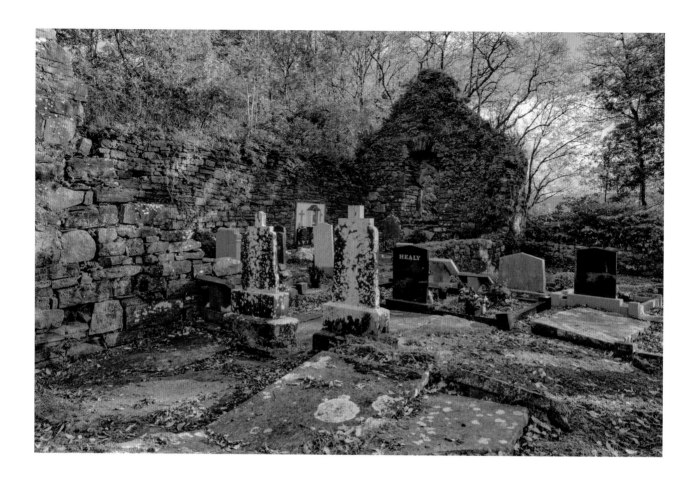

Above: Tarmon Abbey, Lough Allen, Co. Leitrim

Opposite: The Shannon leaving Lough Allen at Bellantra Bridge, Co. Leitrim

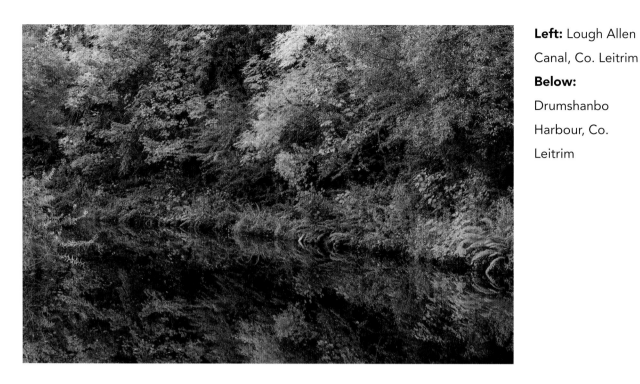

Left: Lough Allen Canal, Co. Leitrim

Below: Drumshanbo Harbour, Co. Leitrim

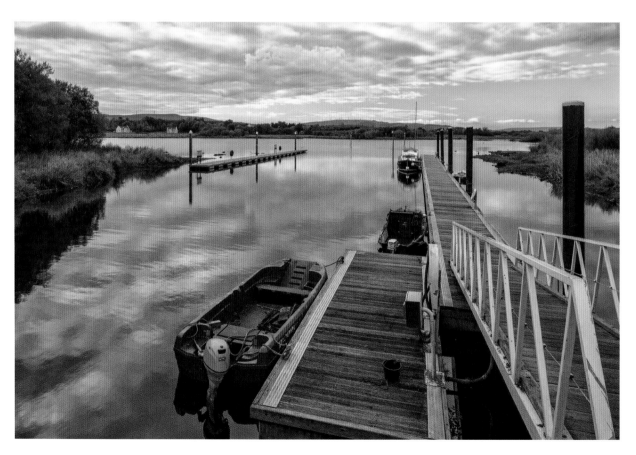

Above: River Shannon, Battlebridge, Co. Leitrim

Right: River Shannon meets Lough Allen Canal, Battlebridge, Co. Leitrim

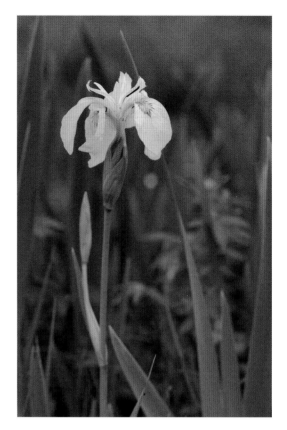

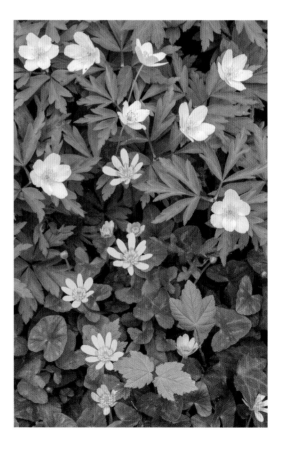

Opposite page

Top left: Water Mint

Top right: Flag Iris

Bottom left: Broad Leaved Pondweed and Bog Pondweed

Bottom right: Lesser Celandine and Wood Anemone

Opposite: Colt's Foot

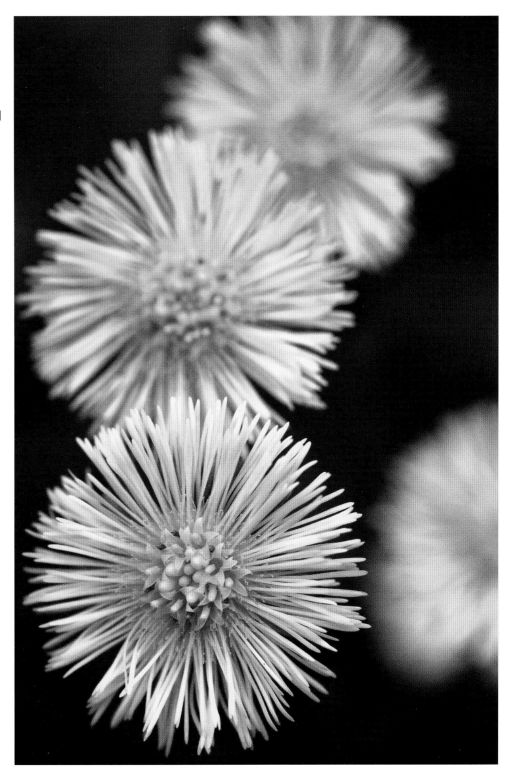

Carrick-on-Shannon, (*Cora Droma Ruisc* – 'the weir of the marshy ridge') is located at a fording point of the Shannon and has been of strategic importance since the earliest of times. Today the town is one of the leading inland waterways resorts and perfectly located to serve the Shannon-Erne-Waterway, Lough Key and the Shannon-Navigation.

A number of historic buildings and monuments provide a glimpse into Carrick-on-Shannon's long history. Among them are the remains of the Castle of Carrickdrumruske, the Town Hall, Hartley Manor, St Mary's Church, St George's Church and the unsettling old workhouse. The latter was built during the Great Famine in 1841 and had a capacity for 800 inmates and, like similar houses all around the country, witnessed horror beyond belief.

During the worst times the workhouse had to deal with over a thousand inmates, many suffering from typhus and dysentery, food and clothing were scarce, there was no bedding just straw to lie in and no heating.

Below: Carrick-on-Shannon Harbour, Co. Leitrim
Opposite left: Carrick-on-Shannon Harbour, Co. Leitrim
Opposite right: Wash Day, Carrick-on-Shannon Harbour, Co. Leitrim

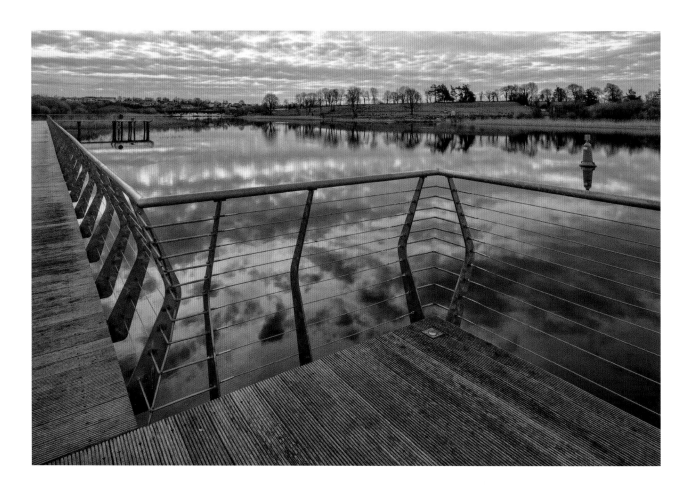

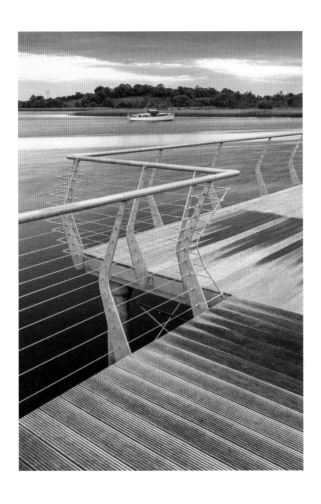

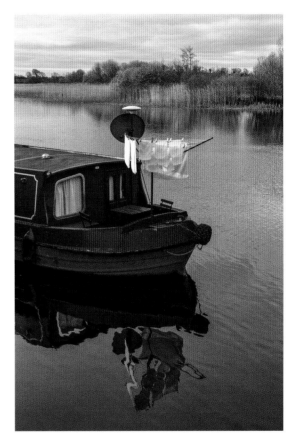

They carved the date above the gate

'Eighteen Forty-Nine'

When they built the workhouse on the hill

of limestone tall and fine.

The people came to drink the soup

Ladled from greasy bowls,

They died in whitewashed wards that held

A thousand Irish souls

M.J. McManus who was born at the Carrick-on-Shannon workhouse

Like skeletons, their features sharpened with hunger and their limbs wasted,

so that there was little left but bones, their hands and arms in particular, being

much emaciated, and the happy expression of infancy gone from their faces,

leaving the anxious look of premature old age.

Cecil Woodham-Smith, from 'The Great Hunger' 1962

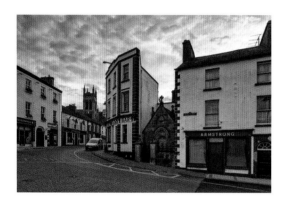

Above: Carrick-on-Shannon, Co. Leitrim
Right: Costello Memorial Chapel, Carrick-on-Shannon, Co. Leitrim
Opposite top: Lough Arrow, Co. Sligo
Opposite bottom: Lough Gara, Co. Sligo

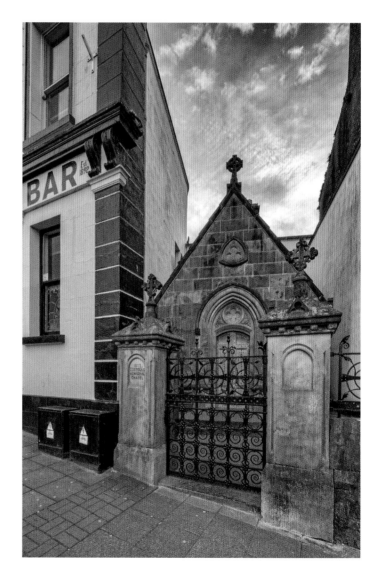

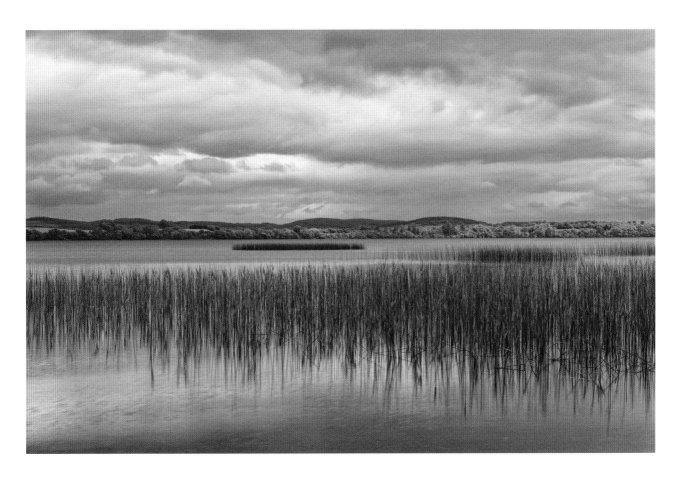

Left: Templeronan
Graveyard, Lough
Gara, Co. Sligo
Opposite top:
Boyle, Co.
Roscommon
Opposite bottom:
Boyle Abbey, Co.
Roscommon

If you halt at Boyle you will find yourself in a very pretty district quite unknown to the tourist. The town lies on a rushing river which, emerging as a broad slow stream from the large bog-fringed Lough Gara, breaks away suddenly just above Boyle to enter Lough Key.

Robert L. Praeger, from 'The way that I went'

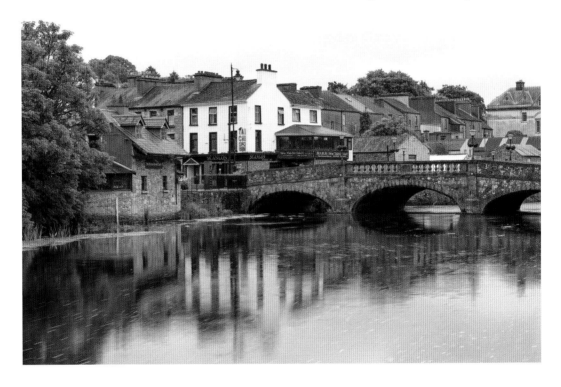

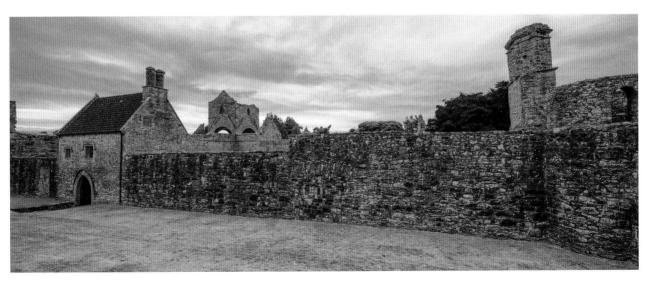

Lough Key is part of the northern Shannon drainage basin. It is fed by the river Boyle which flows from Lough Gara through the town of Boyle into Lough Key. The river Boyle exits Lough Key at Knockvicar and forms two more lakes (Oakport Lough and Lough Eidin) before it joins the Shannon just north of Carrick-on-Shannon.

Lough Key is named after Cé who was the druid of the god Nuada. Legend tells us that he was fatally wounded in battle, but managed to flee. When he reached Curlew Mountain, just west of Lough Key, he saw a vast meadow full of flowers. With his last breath he lay down among the flowers and died. When his grave was dug water burst from the ground and flooded the meadow and formed the lake which was named Loch Cé.

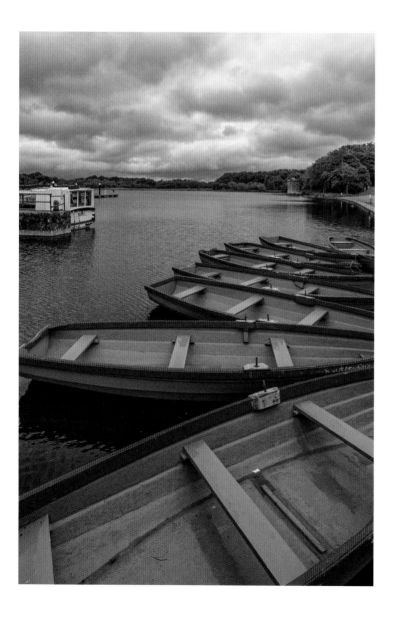

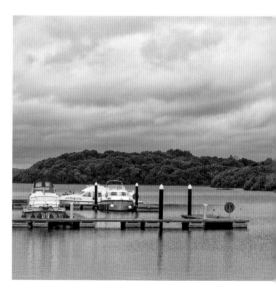

Left: Lough Key, Co. Roscommon
Above: Lough Key Harbour and Castle Island, Co. Roscommon
Opposite: Cootehall Lough, Co. Roscommon

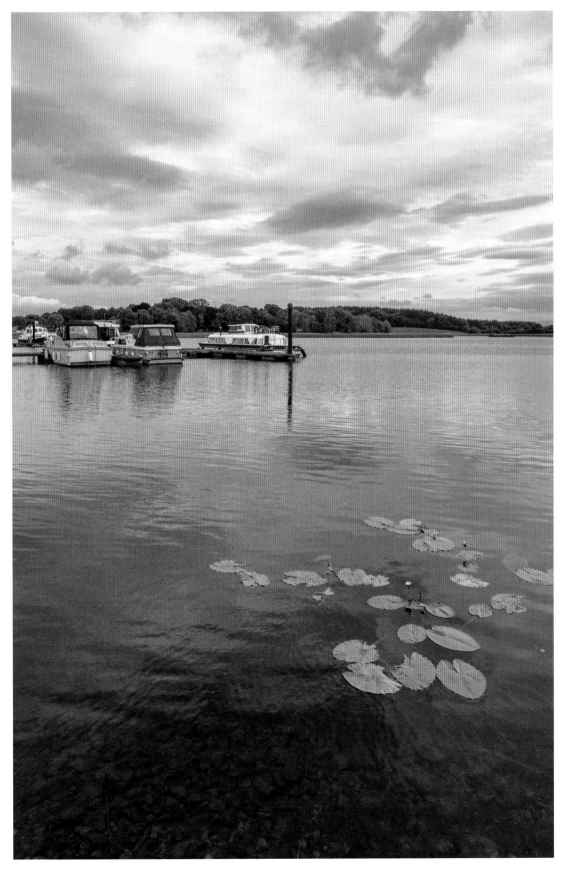

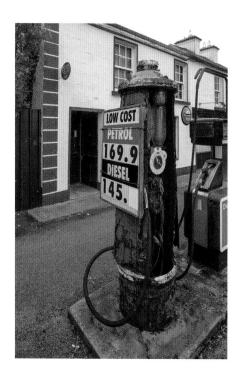

Left: Cootehall, Co. Roscommon

Below: Lough Eidin, Co. Roscommon

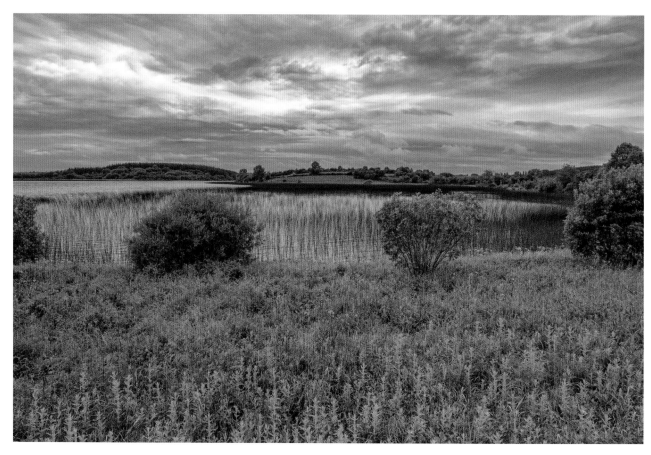

Right: Mallard and American Pekin (top), Mallard (middle) and Pheasant (bottom)

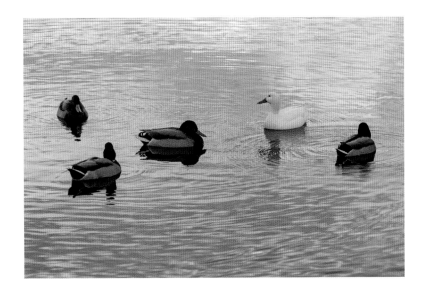

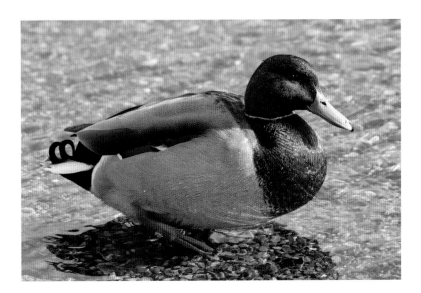

Drumsna, a post-town, containing 427 inhabitants. It comprises about 70 slated houses, several of which are large and handsome. The vicinity presents some of the most beautiful scenes in the county; in one direction are seen the windings of the Shannon through a fertile district, the projection of a wooded peninsula on its course, the heights of Sheebeg and Sheemore, with the more lofty mountain of Slieve-an-erin in the distance; and in the other, the luxuriant and varied swell of Teeraroon, the adjacent part of the county of Roscommon. A pleasing walk through the woods, from which is discovered the windings of the Shannon and the lofty mountains to the north and west, conducts to a sulphurous spring issuing from the verge of a small lake. A little to the south of the town an expansion of the river forms Lough Boffin.

From 'A topographical dictionary of Ireland', 1837

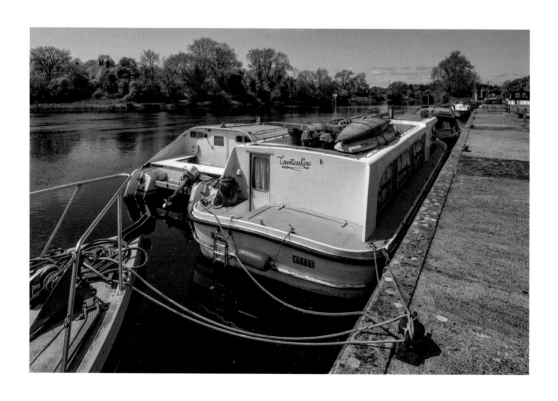

Opposite: Drumsna Harbour, Co. Leitrim. The Jamestown Canal was built in 1848 to bypass a non-navigable section of the Shannon between Jamestown and Drumsna.
Right: Jamestown Priory, Co. Leitrim
Below: The Shannon at Drumsna, Co. Leitrim

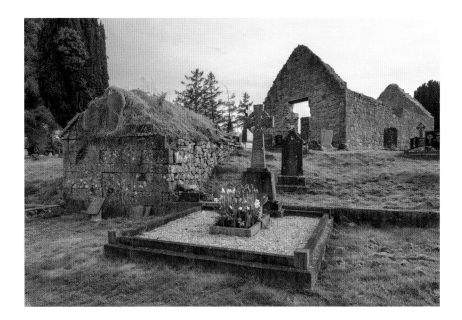

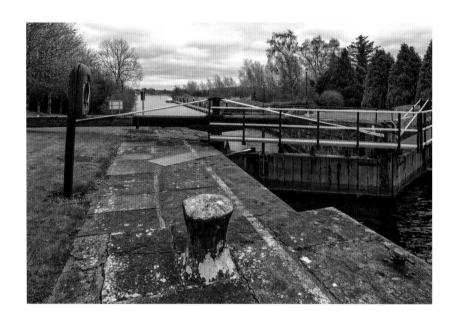

Left: Albert Lock, Jamestown Canal, Co. Roscommon
Below: Albert Lock, Jamestown Canal, Co. Roscommon
Opposite top: Lough Bofin, Dromod, Co. Leitrim
Opposite bottom: Roosky, Co. Leitrim

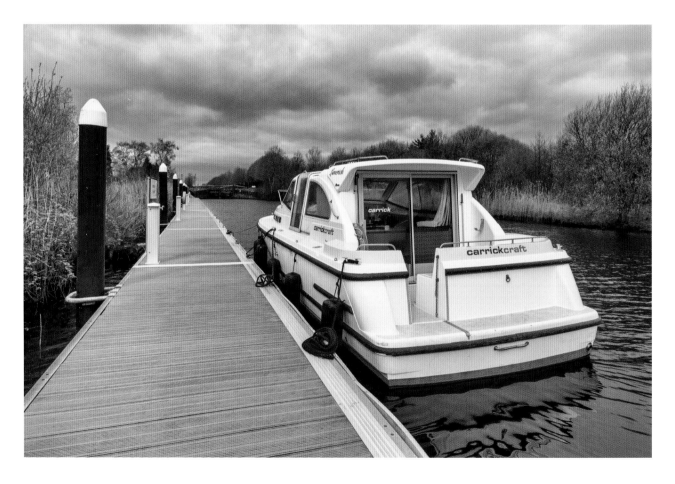

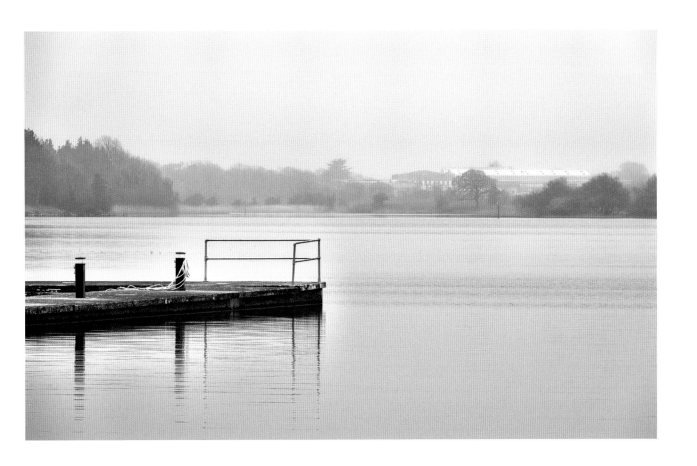

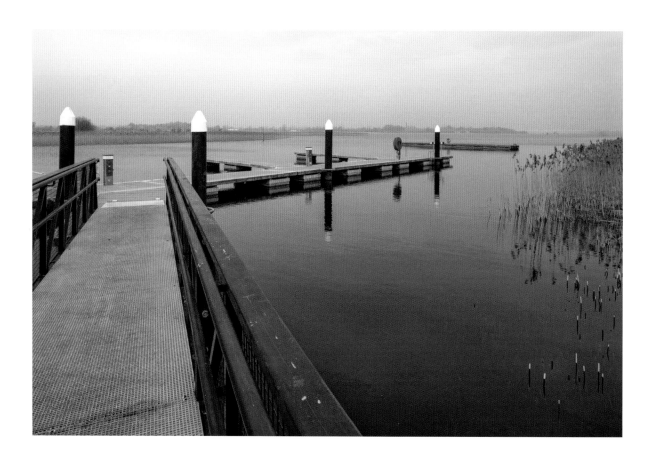

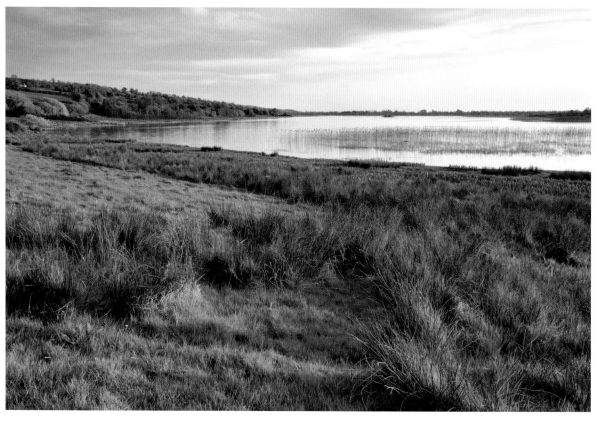

The Royal Canal was originally built for the transportation of freight and passengers, just like its southern cousin the Grand Canal. The canal runs for a total of 145km and took twenty-seven years (1790 to 1817) to build. By the 1830s the canal carried 80,000 tons of freight and 40,000 passengers a year. Only a few decades later the rise of the railway slowly brought an end to the importance of the Royal Canal. In 1845 the Midland Great Western Railway Company bought the canal and considered draining it to build a railway along its bed. This plan however was abandoned and instead the railway line ran alongside the canal from Dublin to Mullingar.

By the 1880s annual tonnage was down to 30,000 and the passenger traffic had all but disappeared from the Royal Canal. During the twentieth century the canal slowly fell into disrepair until in 1974 a volunteer group (Royal Canal Amenity Group) started the task of saving the canal. In 1990 they had managed to reopen 74km of the canal for navigation and in 2010 the whole length of the Royal Canal was formally opened to traffic.

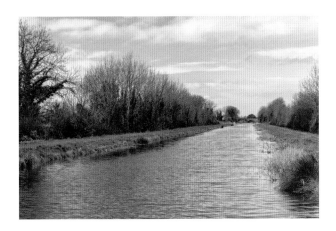 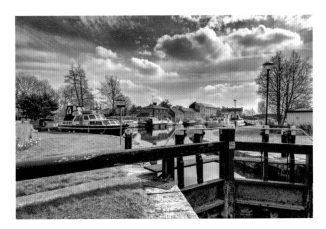

Opposite top: Kilglass Lough, Co. Roscommon
Opposite bottom: Kilglass Lough, Co. Roscommon
Above left: Royal Canal near Ballymahon, Co. Longford
Above right: Royal Canal/Cloondara Harbour, Co. Longford

Lanesborough, a market and post-town, containing 390 inhabitants. This town derived its name from Sir G. Lane, whose lands of Ballyleagh and others in the county of Longford were erected into the manor of Lanesborough by charter of Charles II. The town is advantageously situated for trade on the river Shannon, over which is a bridge of nine arches connecting the counties of Roscommon and Longford. The chief trade is the exportation of corn, pigs, and eggs, of which vast quantities are sent by the Shannon; eggs are also sent to Dublin by the Royal Canal from Killashee, near this town, to which place they are conveyed by land carriage.

From 'A topographical dictionary of Ireland', 1837

The towns of Lanesborough (Co. Longford) and Ballyleague (Co. Roscommon) sit on the northern end of Lough Ree and are, apart from Athlone on the southern end, the main harbours for cruisers who want to explore Lough Ree. Dominating the skyline is the Lough Ree Power Station in Lanesborough. This peat-fired plant replaced the now demolished Lanesborough Power Station in 2004 and is one of three power stations in Ireland that produce electricity by burning milled peat that is harvested from the vast bogs nearby.

Right: Lanesborough
Power Station seen
from Ballyleague
Harbour, Co.
Roscommon

Opposite: Harvested
Peatlands near
Lanesborough, Co.
Longford

Left: Turf Shed, Co. Westmeath

Below: Elphin Windmill, Co. Roscommon

Opposite: St. John's Bay, Lough Ree, Co. Roscommon

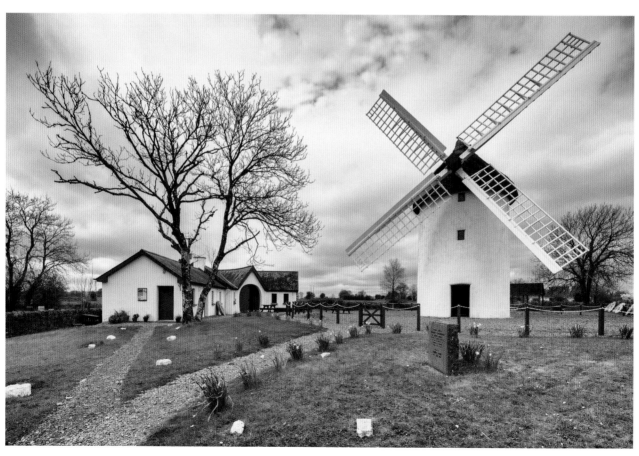

Lough Ree is the second largest lake on the river Shannon and is shared by Co. Longford, Co. Roscommon and Co. Westmeath. The Lake of the Kings, as Lough Ree is also known, is popular for fishing and boating despite the stories about a vicious lake monster living in its depths.

'It was moving. It went down under the water and came up again in the form of a loop. The length from the end of the coil to the head was six feet. There was about eightten inches of head and neck over the water. The head and neck were narrow in comparison to the thickness of a good-sized salmon. It was getting its propulsion from underneath the water, and we did not see all of it.' This is the description three priests gave after they encountered the beast while being out on a fishing trip in May 1960. The three clergymen were not the first to have strange encounters on the lake: cabin cruisers striking a big underwater object at the deepest part of the lake, a fisherman being dragged across the lake before he managed to cut his fishing line and a number of fishermen hauling in their nets only to find enormous gaping holes in them are just a few of the many Lough Ree monster stories.

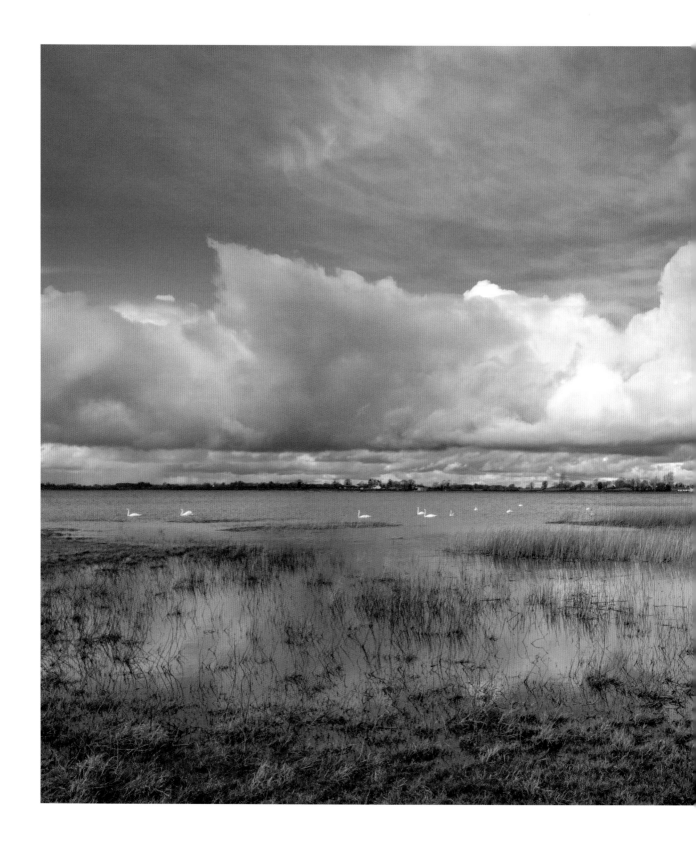

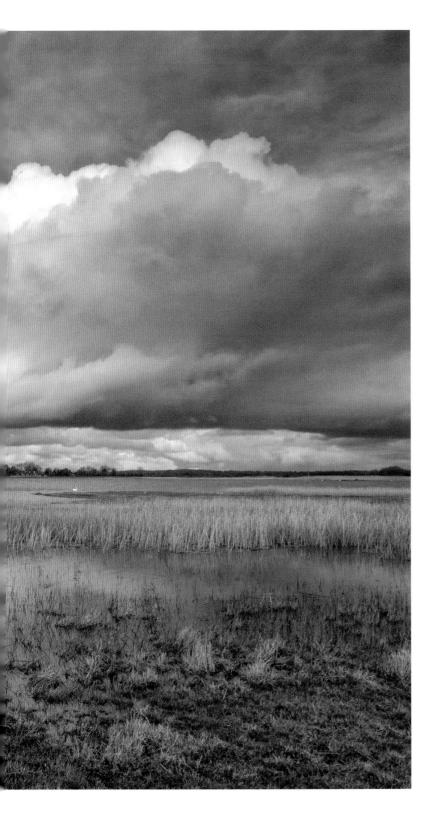

Left: Saints Island, Lough Ree, Co. Longford

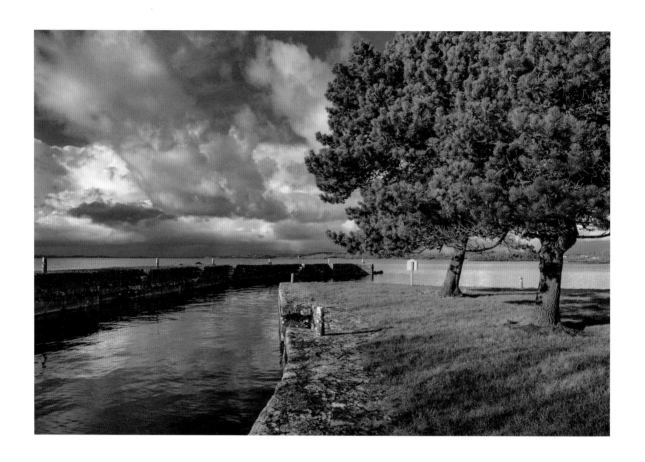

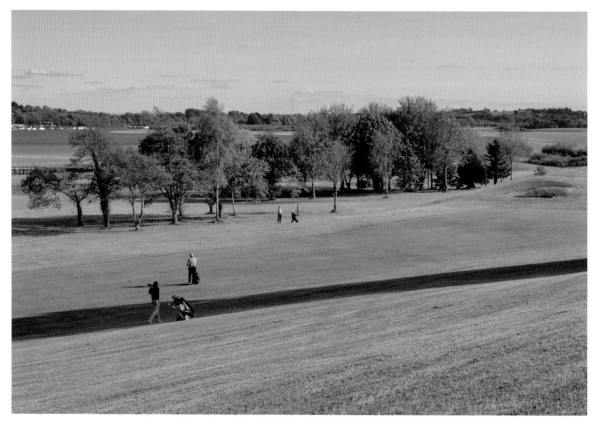

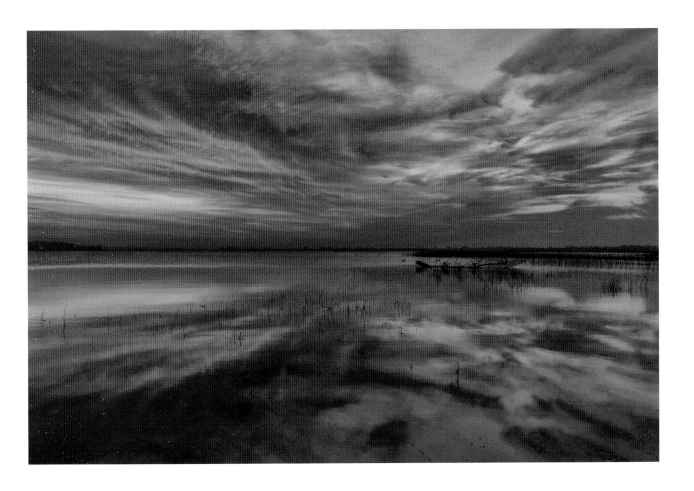

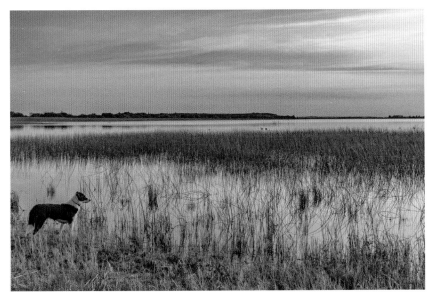

Opposite top: Barley Harbour, Lough Ree, Co. Longford
Opposite bottom: Glasson Golf Club, Co. Westmeath
Above: Inny Bay Sunset, Lough Ree, Co. Westmeath
Left: Watching the birds, Lough Ree, Co. Westmeath

Rinn Duin is a peninsula on the western shore of Lough Ree. On this peninsula stand the remains of an Anglo-Norman town including castle, church, windmill and town walls with gatehouse and towers. Although this settlement was rather short lived, built in 1227 and destroyed and ruined only 150 years later, it gives a truly unique glimpse in to Ireland's medieval past.

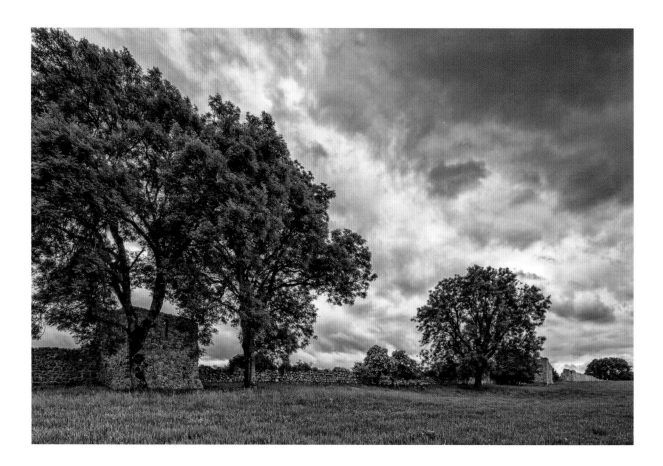

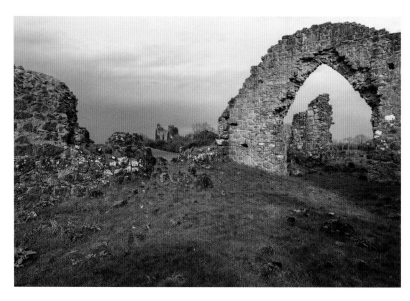

Saints' Island is one of the many islands on Lough Ree and connected to the mainland via a causeway. It is a remote and peaceful place that is best known for the remains of a monastery that was founded in the sixth century by St Ciaran who then moved on to establish Clonmacnoise.

Opposite top: Town Wall and Tower, Rinn Duin, Co. Roscommon
Opposite bottom: Church and Castle, Rinn Duin, Co. Roscommon
Right: Saints Island Monastery, Lough Ree, Co. Longford
Bottom right: Hawthorn on Saints Island, Lough Ree, Co. Longford

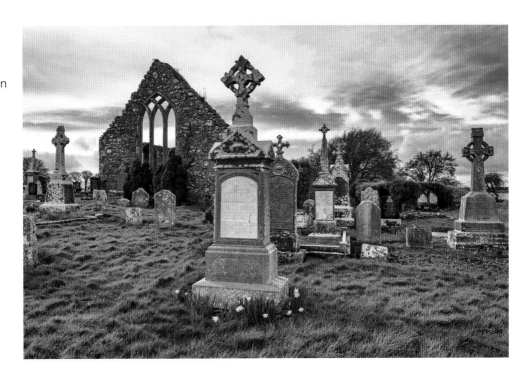

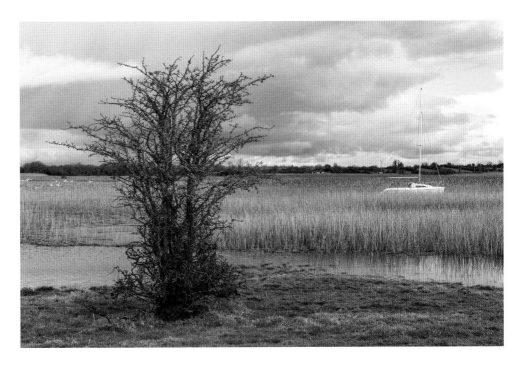

Athlone guards the southern end of Lough Ree and is, after Limerick, the biggest town along the Shannon. Athlone grew around an important crossing point on the Shannon and also takes its name from it: *Athluain*, 'The Ford of Luan'.

The earliest archaeological finds date back to the Bronze Age and a number of early Christian grave slabs also suggest that the Ford of Luan was the site of an unrecorded monastery. King Turlough O'Conner built the first bridge across the Shannon as well as the first fort in 1129. During the twelfth century the Anglo-Normans built a motte and subsequently the castle.

Over the following centuries, Athlone remained the vital main crossing over the Shannon in the midlands, facing and surviving wars and sieges. After things had calmed down in the nineteenth century Athlone grew prosperous on the back of Athlone Woollen Mills, the Shannon Navigation and the arrival of the railway in 1850.

Today a number of buildings are a constant reminder of Athlone's long and eventful history: King John's Castle and St Peter and Paul's Church with its twin towers overlooking the Shannon. The Custume Barracks, built in 1691 and named after Sergeant Custume who defended Athlone Bridge against the forces of King William III in 1690, today is home to several regiments of the Irish Defence Forces. Athlone also claims Ireland's (and probably even the world's) oldest pub: Sean's Bar (formerly Luain's Inn) dates back to the 10th century. The pub actually pre-dates the town and it is thought that the innkeeper assisted travellers in crossing the ford across the Shannon and the town later grew around the inn. During renovations in 1970 it was discovered that some walls of the bar were made of wattle and wicker and a number of old coins dating back to 900AD were also found.

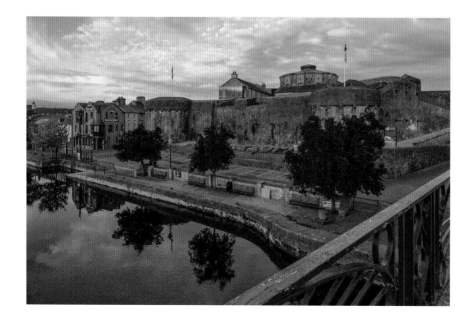

Left: Athlone Castle, Co. Westmeath

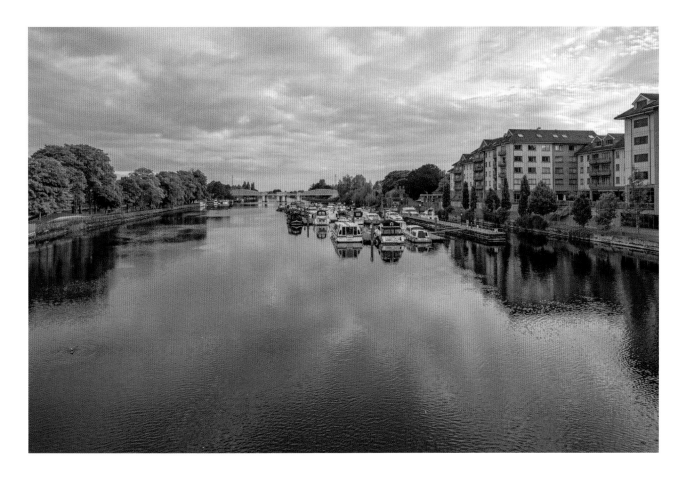

Above: The Shannon at Athlone, Co. Westmeath

Below left: Church of Saints Peter and Paul, Athlone, Co. Westmeath

Below right: The Old Town, Athlone, Co. Westmeath

Below left: Athlone Weir, Athlone, Co. Westmeath

Below right: Sean's Bar, Athlone, Co. Westmeath

Bottom left: John's Bookshop, Athlone, Co. Westmeath

Bottom right: Helen Conneely of Celtic Roots Studio, Athlone, Co. Westmeath

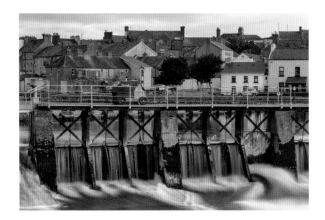

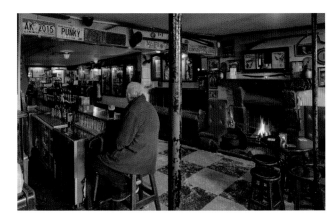

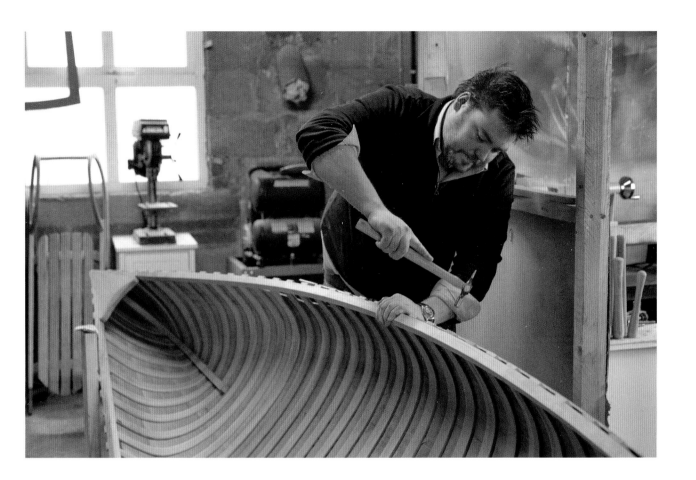

Above: Jonathan Russell founded Nua Canoe in 2016 and builds his traditional wood-canvas canoes, which are based on a Canadian design, in the heart of the Westmeath lakelands.

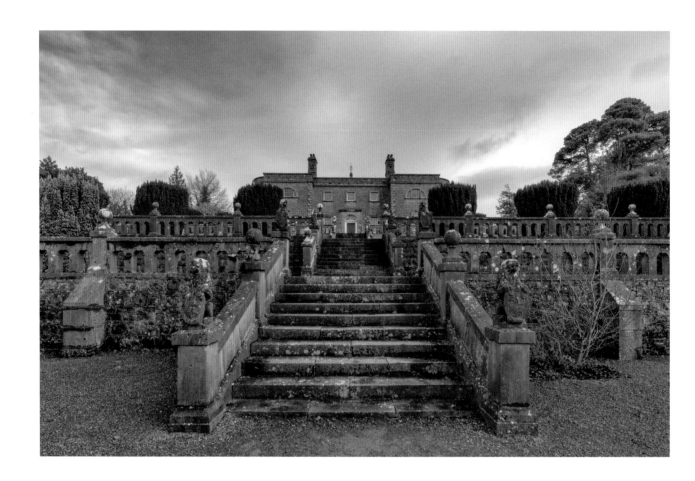

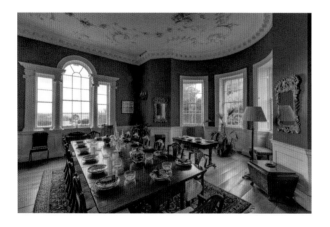

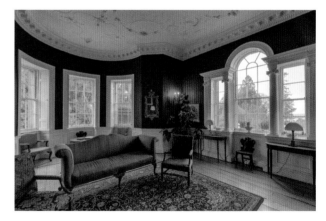

Top: Belvedere House, Co. Westmeath

Above left: Belvedere House, Dining Room, Co. Westmeath

Above right: Belvedere House, Reading Room, Co. Westmeath

Belvedere House was built in 1740 for Robert Rochfort (later Lord Belvedere) as a Georgian villa at the shores of Lough Ennell. Lord Belvedere became known as the Wicked Earl after it emerged that he had kept his wife imprisoned for thirty-one years after she had an alleged affair with his younger brother Arthur.

Top: Fisherman's Cottage at Dún Na Sí Heritage Park, Moate, Co. Westmeath

Right: Dún Na Sí Heritage Park, Moate, Co. Westmeath

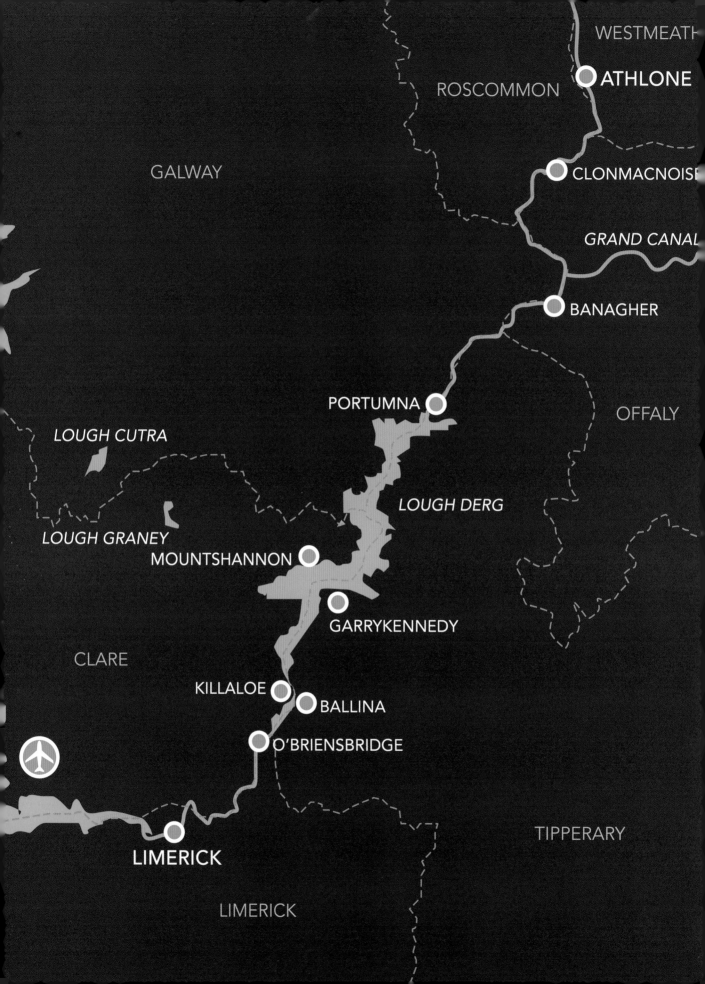

CHAPTER 2:

FROM ATHLONE TO LIMERICK

From Athlone the Shannon winds its way slowly south-westward through the flat and tranquil plains of Co. Offaly and Co. Galway towards Lough Derg. On this part of its journey the river wanders mostly alone. Only at the towns – Shannonbridge, Shannonharbour and Banagher – and at the old monastic city of Clonmacnoise can the river be accessed from a road.

In Portumna the Shannon enters Lough Derg and exits the lake again further south at Killaloe and Ballina. From here it is only a short way to the city of Limerick, but there's a lot happening to the river on that short stretch. Just upstream from O'Briensbridge, the Shannon separates in two: the main flow winds its way southward through O'Briensbridge and Castleconnell before turning west at Castletroy. The artificial headrace canal that powers the hydroelectric station at Ardnacrusha flows south-westwards and joins the Shannon again south of Parteen. From there the Shannon makes its way through the heart of Limerick City and towards the end of its journey, the Shannon Estuary.

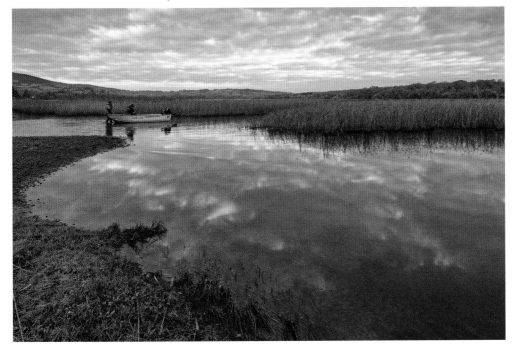

Left: Fishermen at Lough Graney, Co. Clare

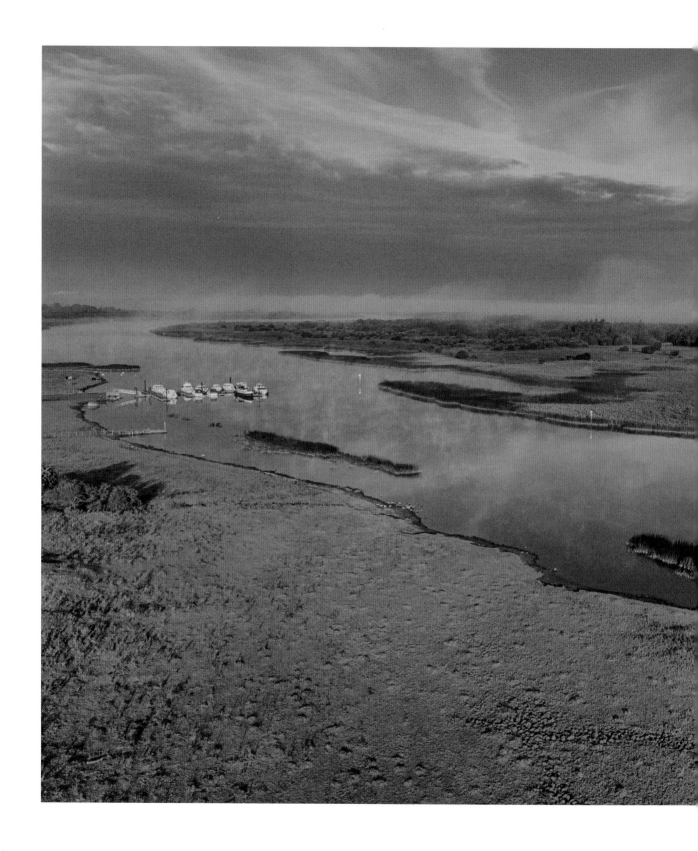

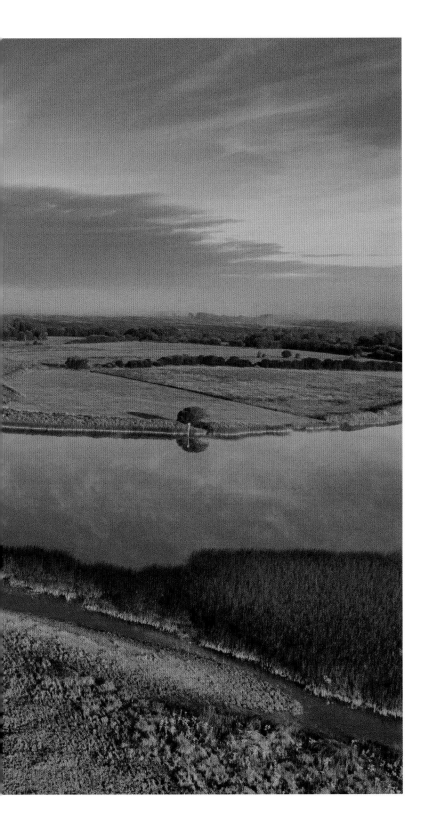

Left: The Shannon and
Clonmacnoise jetty, Co. Offaly

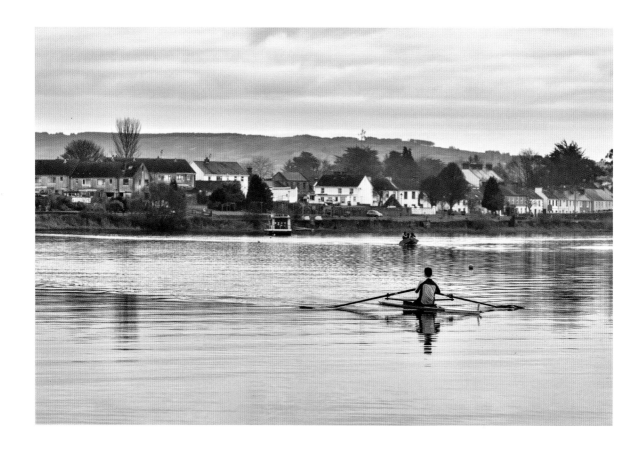

Above: Rowers on the Shannon, O'Briensbridge

Below: Kayaks, Lough Derg, Co. Tipperary

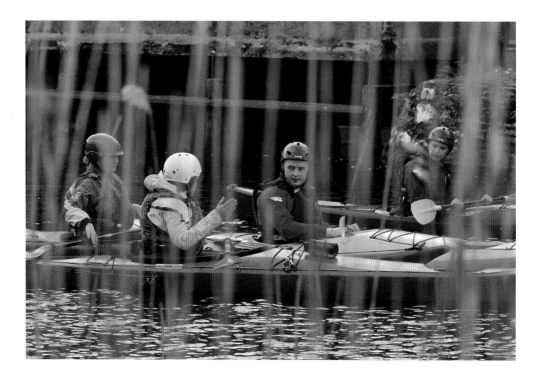

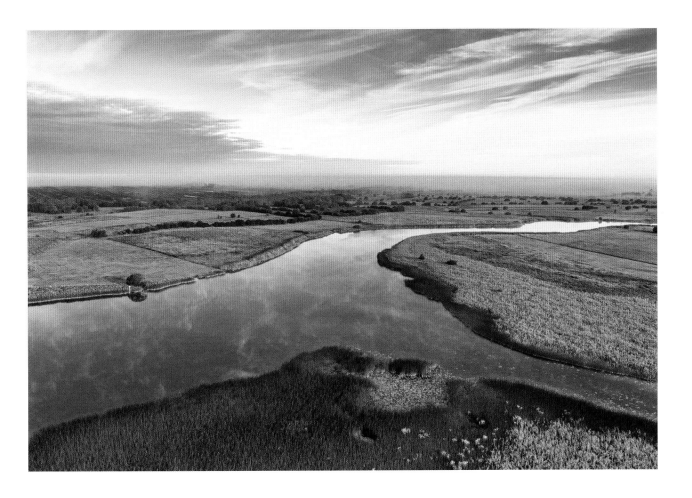

Above: The Shannon at Clonmacnoise, Co. Offaly

Bottom left: Winter at the Shannon near Clonmacnoise, Co. Offaly

Bottom right: Summer Dawn, Clonmacnoise, Co. Offaly

Clonmacnoise sits almost at the centre of Ireland at the crossroad of the River Shannon and the Eska Riada, once the main east-west passage through the country.

Clonmacnoise was founded around 550 by St. Ciaran and grew from a humble monastery into a centre of learning – what we would call a university today – around which a major city grew. By the eighth century Clonmacnoise was also a centre for trade and commerce and the monastery and the town around it had grown extremely wealthy. What followed was the fate of many of the rich monasteries of the time: Clonmacnoise was braided again and again by Vikings, Anglo-Normans and neighbouring Irish kings. This, and a reformation of the Church, started the slow decline of Clonmacnoise and by the seventeenth century it was in ruins.

But Clonmacnoise hasn't lost its atmosphere. Standing among the ruins of a cathedral, seven churches, two round towers, high crosses and the largest collection of early Christian grave slabs in Western Europe it is easy to imagine the singing of the monks, the hustle and bustle of the crafts, and tradespeople, and the students on the way to their lectures.

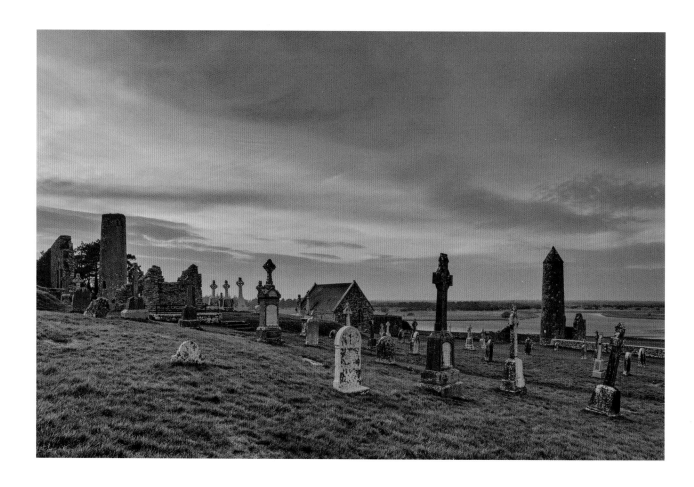

Opposite: Clonmacnoise, Co. Offaly

Right: Temple Ciaran, Clonmacnoise, Co. Offaly

Bottom: Cathedral doorway at Clonmacnoise, Co. Offaly

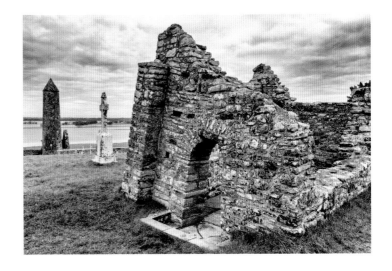

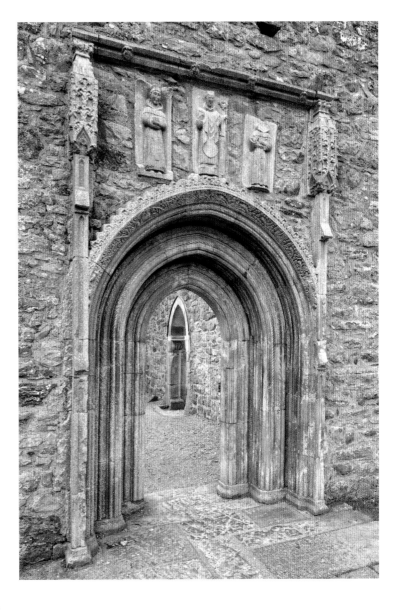

The Shannon Callows stretch from south of Athlone to north of Portumna on both sides of the Shannon. This seasonally flooded grassland has never been extensively cultivated for farming. Each winter the floodwaters bring plentiful nutrition to the meadows of the Callows, which turn into a sea of grasses and wildflowers each summer. These meadows are only cut once a year for hay and grazing cattle keep willows and other encroaching shrubs at bay. As a consequence the Shannon Callows are a haven for birds and wildflowers.

The black-tailed godwit, curlew, snipe, golden plover, lapwing, redshank and sandpiper are just some of the bird species recorded. The Shannon Callows have also been a stronghold for one of Ireland's most elusive birds, the once common corncrake. In 2014 only one calling male was recorded, in 2015 the Callows stayed silent and it seems this bird has disappeared from the Shannon Callows for good. The cuckoo flower, water mint, marsh bedstraw, common sedge, white clover, marsh marigold, creeping buttercup and meadowsweet are some of the common wildflowers.

Below: The flooded Shannon Callows in winter, Co. Offaly

Above: Shannon Callows meadow in summer, Co. Offaly

Below left: The Shannon at Shannonbridge, Co. Offaly

Below right: Shannonharbour, Co. Offaly

Banagher, a market and post-town, containing 2636 inhabitants. This town is situated on the side of a hill, on the south bank of the Shannon, just above the influx of the little Brosna river, and at the junction of the roads from Parsonstown to Cloghan and Eyrecourt. The bridge, connecting it with the Galway shore, is one of the oldest across the Shannon: it consists of several small arches with projecting piers, and is very narrow and inconvenient, but of great strength and solidity. Latterly, however, this bridge, which is supposed to have stood between 400 and 500 years, has shown numerous symptoms of decay. The town comprises about 500 houses, mostly well built; the streets are Macadamised. There are a distillery, brewery, malt-house, and tanyards; and the town has a good general trade with the rural population of the surrounding district. It is well situated for trade, having the advantages of steam navigation to Limerick and the sea, and of water communication with Athlone, Ballinasloe, and Dublin: the introduction of steam navigation on the Shannon, has greatly benefited the general trade of this place.

From 'A topographical dictionary of Ireland', 1837

Opposite top: Banagher Marina, Co. Offaly
Opposite bottom: The Shannon at Banagher, Co. Offaly

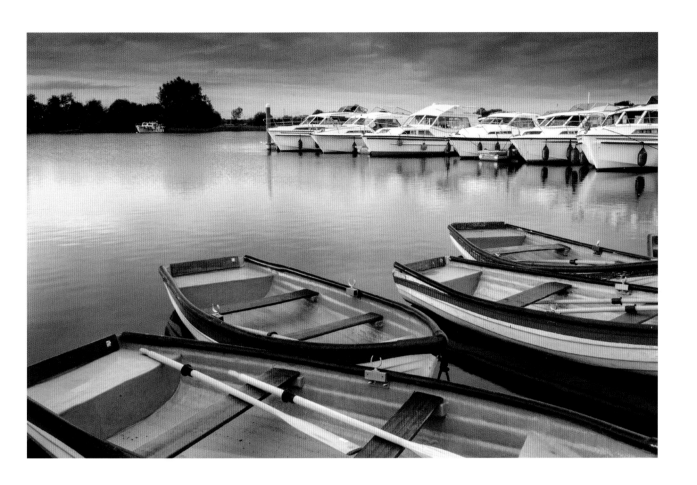

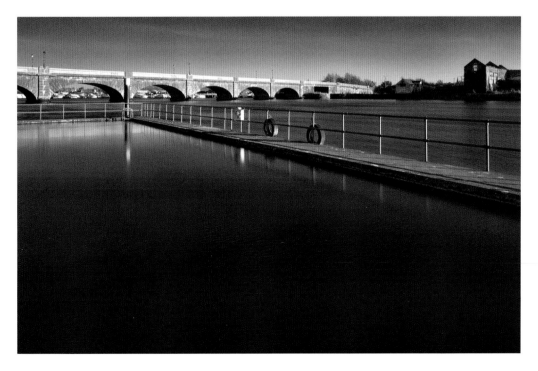

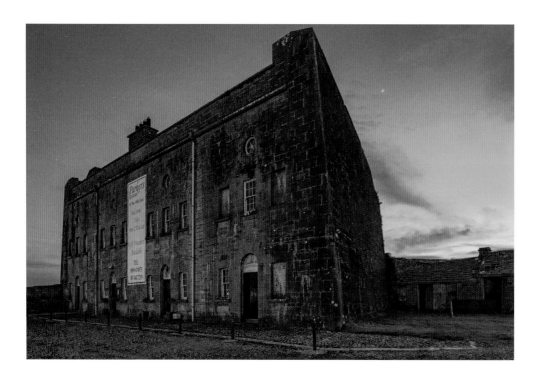

Left: The battery at Shannonbridge is now a restaurant, Co. Galway

Below: Caponniere at Shannonbridge, Co. Galway

At the turn of the nineteenth century there was a constant fear in England and Ireland of a possible Napoleonic invasion. As a defence, a line of Martello Towers and batteries were built not only along the coast, but also along the Shannon. These were intended not to prevent an invasion from the river itself, but also from the west coast should the defences there fail. This is why most structures are situated on the western side of the river.

Shannon-Bridge, a village and fortified military station. The Roscommon end of the bridge is occupied by a military work, which forms a 'tete de pont' capable of accommodating a small garrison. The public road wends between the barracks and the fort, passing through a strong gate; and the place, besides being defended by the guns of the fort is protected on the Connaught side by an advanced redoubt on a rising ground to the north of the highway. The fortifications are closely similar to those at Banagher but the barracks are larger, and the battery more conspicuous. Shannonbridge is one of the three fortified passes still maintained upon the Shannon, the other two being Banagher and Athlone.

Parliamentary Gazetteer of Ireland, 1844-45

The Grand Canal is the southernmost of the two canals that connect Dublin with the Shannon. Works started in 1756 and completed in 1803. The biggest challenge of the project was getting across the raised bogs of the midlands – it took five years to cross the Bog of Allen alone. In total the Grand Canal runs for 140km with forty-three locks and is linked to the river Barrow at Athy. For over 150 years the canal was used to transport cargo and passengers, but became redundant with the improvement of the road and rail network. The last cargo boat passed through the Grand Canal in 1960.

After that the canal fell into disuse and became a dumping ground. In 1986 ownership was given to the Office of Public Works who made it a priority to clean up the canal and develop it for public use. Today the Grand Canal is part of Waterways Ireland and is used for a number of leisure activities. It joins the Shannon at Shannon Harbour.

Below: Lock 33 at the Grand Canal near Belmont, Co. Offaly

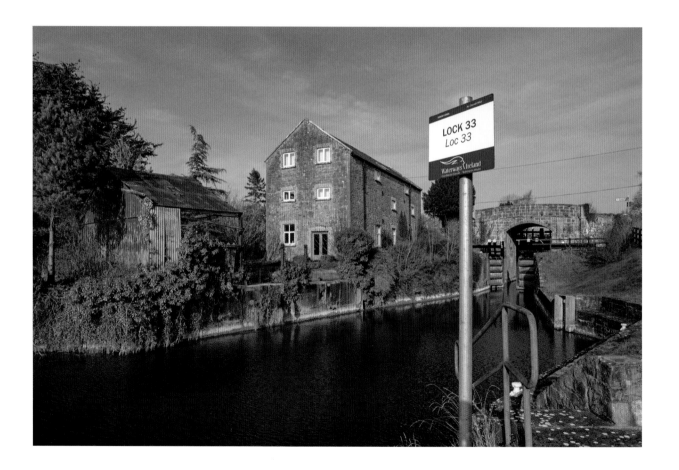

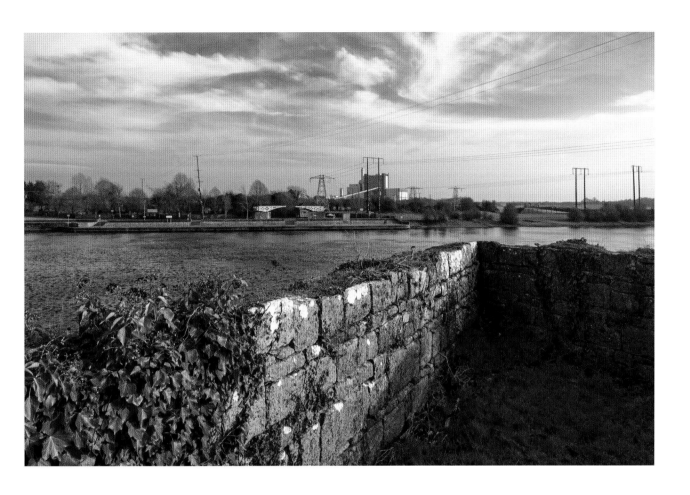

Above:

Shannonbridge
Power Station and
Quay, Co. Offaly
Right: Grand Canal
near Belmont, Co.
Offaly

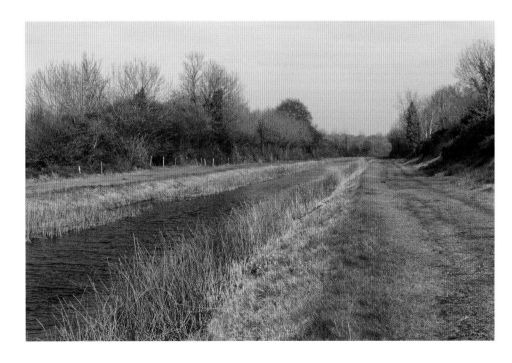

Top left: Shop window, Shannonbridge, Co. Offaly

Top right: Larkin's Pub, Garrykennedy, Co. Tipperary

Above left: O'Briensbridge, Co. Clare

Above right: Mountshannon, Co. Clare

The story of Clonfert starts in the sixth century when St Brendan the Navigator founded a monastery here, which hosted some 3,000 monks in its heyday. The only remains of the original monastic settlement is a yew walk in the woodland beside the cathedral and graveyard. The cathedral dates from the twelfth century and is best known for its elaborate doorway, attributed to Peter O'Moore, bishop of Clonfert from 1161 to 1171.

The doorway features six columns of decorated brown sandstone and a later inner column made from 15th-century blue limestone. All columns are decorated with shapes, patterns, human and animal heads and even a mermaid. On top of the doorway sits a tall pediment consisting of triangles with alternating human heads.

Below: Clonfert Cathedral, Co. Galway

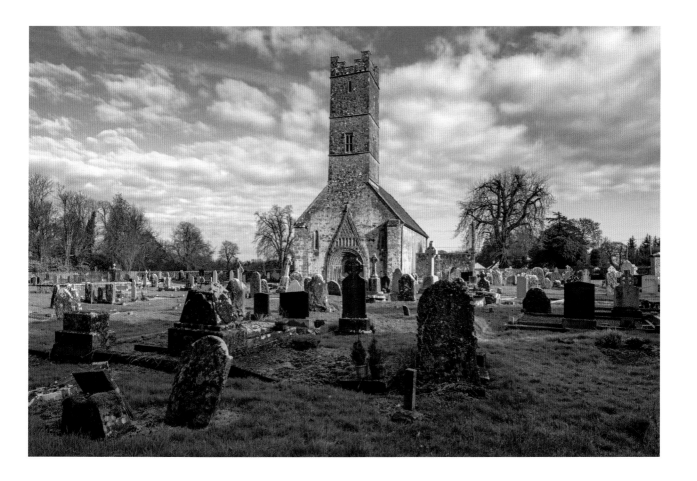

Though time has since flown fast away

The Shannon rolls as ever

And oft upon a moonlit bay

That hems the noble river

The midnight wanderer has espied

A steed while o'er the water

A tiny bark is seen to glide

With Clanrickarde's only daughter.

This ballad describes the tragic end of Lord Clanrickarde's daughter who fell in love with a young local chieftain named O'Connell. The couple eloped, but their boat capsized near Portland Island and she drowned. It is said her ghosts is still wandering around Portland Island.

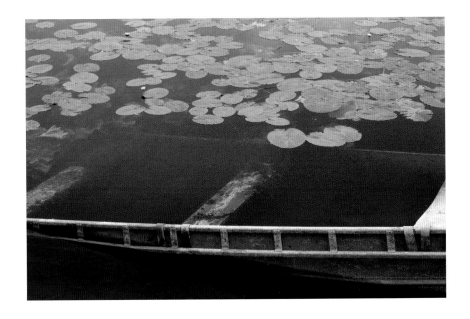

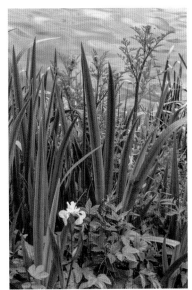

Opposite bottom: Trees, Lough Derg, Co. Clare

Above left: Boat and Yellow Water Lilly, Banagher, Co. Offaly

Above right: Flag Iris at the Shannon, O'Briensbridge, Co. Clare

Below left: Turlough Dandelion, Lough Bunny, Co. Clare

Below right: Summer at the Shannon Callows, Co. Offaly

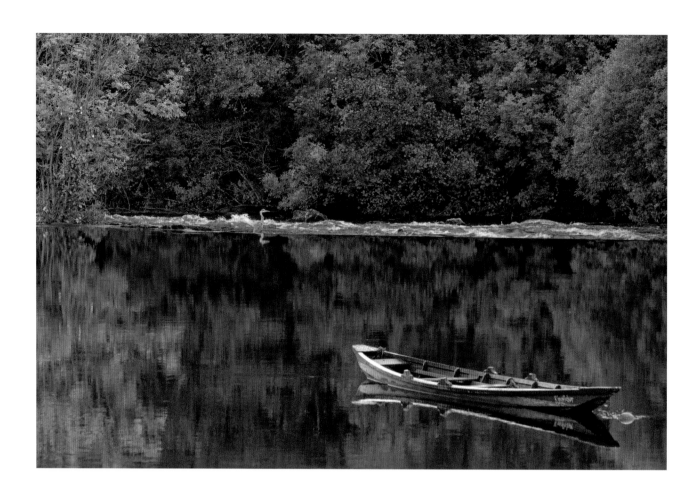

Above: Grey Heron, Shannon near Castleconnell, Co. Limerick

Left: Mute Swans, Shannon near Castleconnell, Co. Limerick

Above: Whooper Swans on a Turlough, The Burren Wetlands, Co. Clare

Below left: Tufted Ducks, Dromore Nature Reserve, Co. Clare

Below right: Coot, Lough Derg, Co. Tipperary

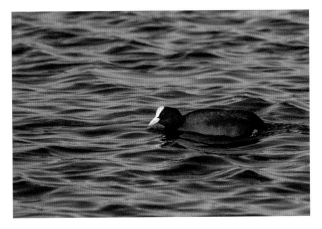

Portumna is one of the main harbours along the Shannon. The market town is best known for its castle and gardens, Dominican friary and forest park which all lie close together at the south-eastern end of the town.

On the opposite end of the town, in stark contrast to the luxury and beauty of the other end of Portumna, stands a reminder of one of the darkest chapters of Irish history: the workhouse. The Portumna Workhouse opened its doors in 1852 and operated until the early twentieth century. It was part of the national workhouse scheme, 'The most feared and hated institution ever established in Ireland'. The scheme was founded to support the poorest of the poor, following an English model. The whole family had to enter together; in exchange for work they were offered shelter and food. What was in theory a good idea didn't work very well in practice: families were split up and had to dwell in different buildings, the food – mainly porridge, milk and potatoes – was of poor quality and the dormitories were often cold, damp and draughty. Rules were plentiful and strict and the staff tough at best and cruel at worst.

While in the years before the Great Famine the workhouses could cope with the influx of people, the failing potato crop introduced an even harsher reality and from late 1846 onwards overcrowding was added to the already bad conditions inside the workhouses. Malnourishment of the inmates became the norm, disease was common and spread fast among the workhouse population. In Portumna the pathway to the workhouse became known as Casán na Marbh, Pathway of Death. It is said there were only two ways to escape the workhouses: death or emigration.

In the late nineteenth century the workhouses started to extend their patient care and started to accept non-residents to their infirmaries. After the workhouse system was officially abolished in the 1920s many of the buildings stayed open as community hospitals or homes. The reputation, however, persisted and for decades people were fearful of spending any time inside those buildings.

The Portumna Workhouse was restored by the South Galway IRD (Integrated Rural Development Company) and opened its doors to the public in 2011.

Opposite top: Portumna Castle, Co. Galway
Opposite bottom: Portumna Friary, Co. Galway

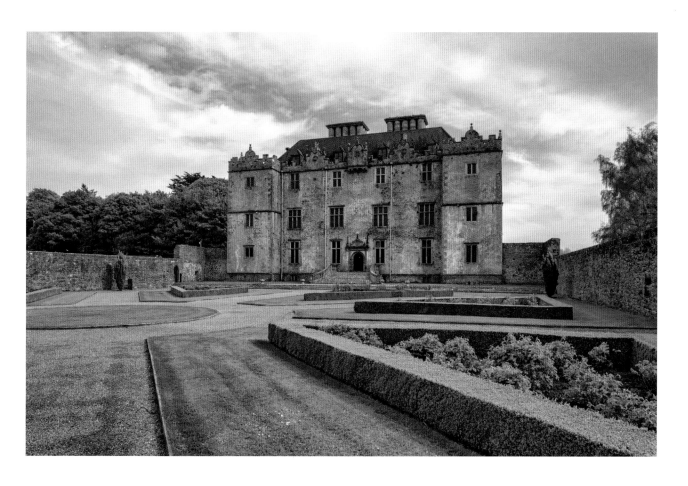

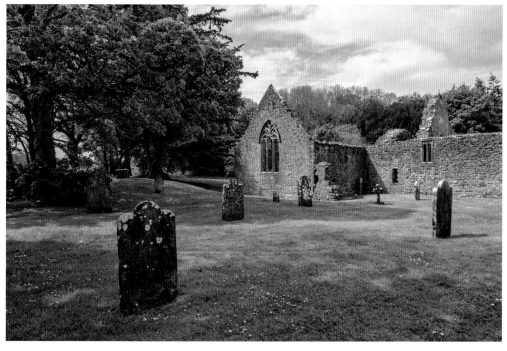

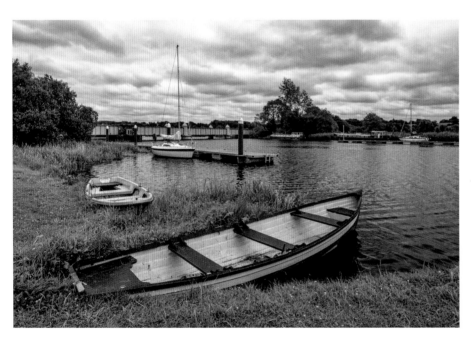

Left: Portumna Forest Park, Co. Galway
Middle: Portumna Bridge, Co. Galway
Bottom left: Portumna Workhouse, Co. Galway
Bottom right: Sleeping platforms at Portumna Workhouse, Co. Galway

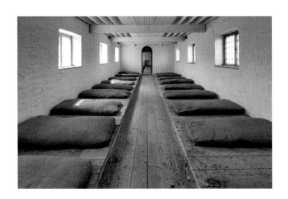

Already the heather purpled moorlands of the Slieve Aughty Mountains were marching beside us along the Galway shore. Beyond, blue in the summer air, we could see the mountains guarding the approach to Killaloe, Slieve Bernagh – the Gapped Mountain – in the County Clare beyond Scariff Bay, and opposite, in Tipperary, majestic Tountinna, highest point of the Arra Mountains, with the Silvermines and Keeper Hill, highest of them all, closing the far horizon. This splendid amphitheatre of mountains looming ahead made a fitting climax to out voyage and made us realize what we should have missed had we been unable to visit Lough Derg.

L. T. C. Rolt, 1946 (from 'Green and Silver', London 1948)

Lough Derg is the biggest of the lakes along the Shannon and the third biggest on the island of Ireland. It is shared by the counties of Galway, Clare and Tipperary, covers an area of 130 square km and reaches a depth of 36m.

Its name derives from the Irish, *Loch Deirgdheirc,* meaning 'the Lake of the Red Hollow'. Legend tells us that Aithirne, the most famous poet of his time, travelled through Ireland, offering his services to the local kings and demanding – and receiving – the most outrageous payments in return. Eochy Mac Luchta, who resided between Mountshannon and Scariff, was known as the one-eyed king of South Connacht and Thomond. After Aithirne had entertained Eochy for some weeks it was time for Aithirne to move on. When the king asked him what he wanted for his services the poet simply answered: 'Your eye'. King Eochy complied and when he washed his now empty eye socket by the shore of the lake one of his servants remarked that the lake turned red with his blood.

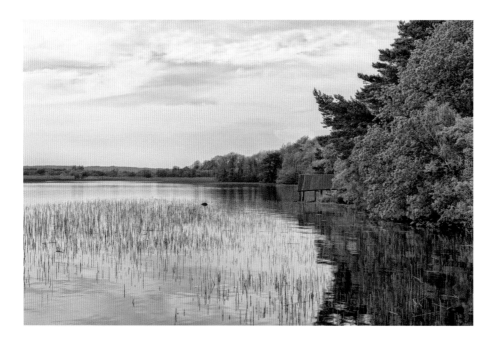

Left: Rosmore Pier, Lough Derg, Co. Galway
Below: Lough Derg near Scariff, Co. Clare

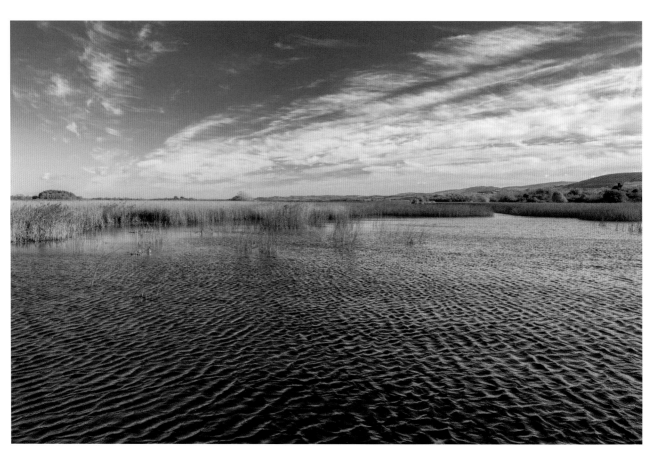

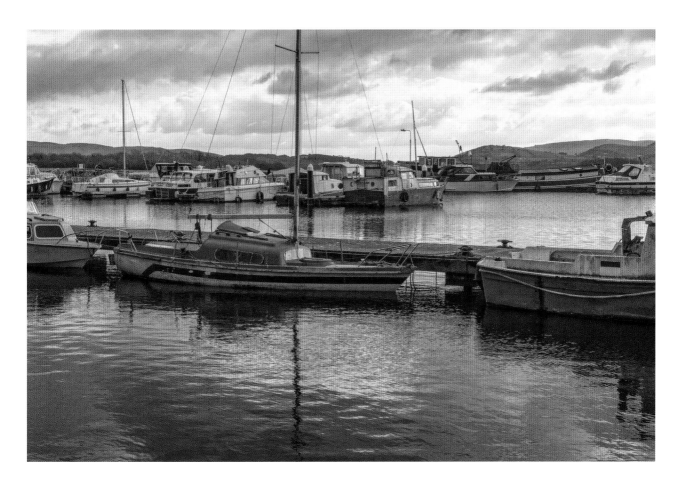

Above: Mountshannon
Harbour, Co. Clare
Right: Dromineer Marina
and Castle, Co. Tipperary

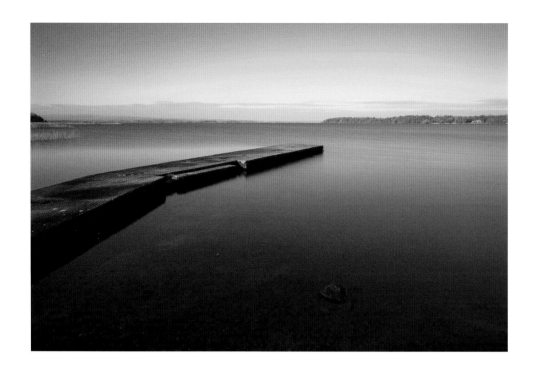

Left: Dromineer, Lough Derg, Co. Tipperary

Below: Garrykennedy Harbour, Co. Tipperary

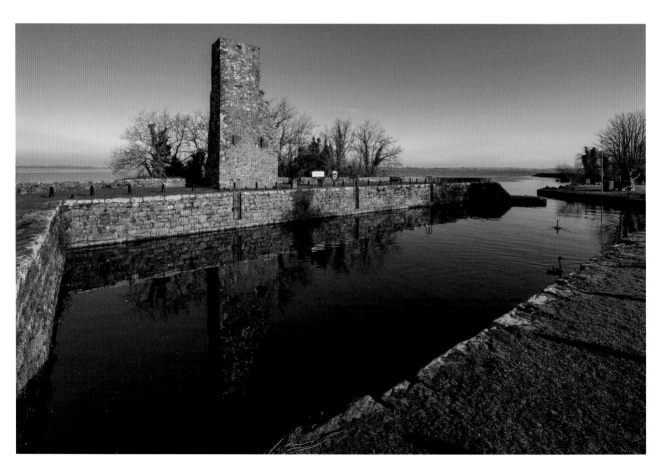

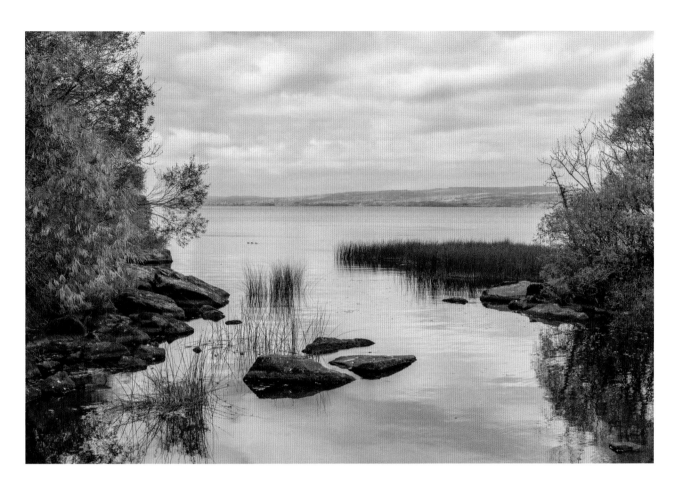

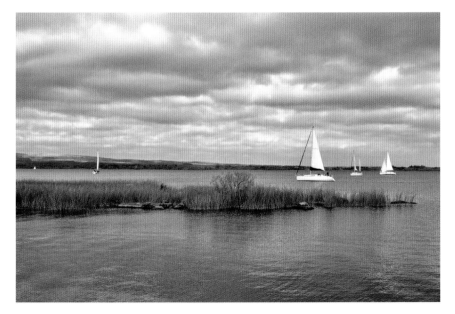

Above: Garrykennedy, Lough Derg, Co. Tipperary

Left: Yachts at Garrykennedy, Co. Tipperary

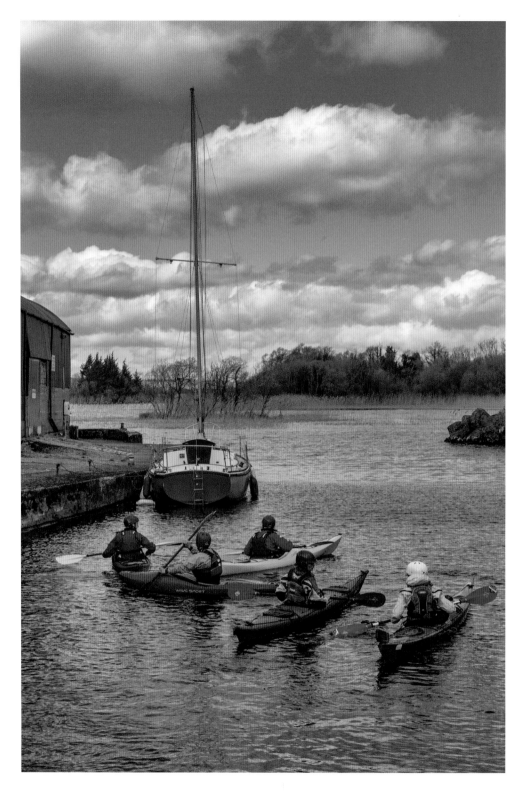

Left: Kayaks on Lough Derg, Kilgarvan Quay, Co. Tipperary
Right: The Lookout, Lough Derg, Co. Tipperary

And if you come to Castletown

and stand at the Lookout,

'tis there you'll see the famed Lough Derg,

well filled with eel and trout,

where the small birds sing

the welcome spring

and the gull and curlew

Do fly in line, and pass their time

round the village of Portroe

Denis Lyons (1864-1959), from 'The Village of Portroe'

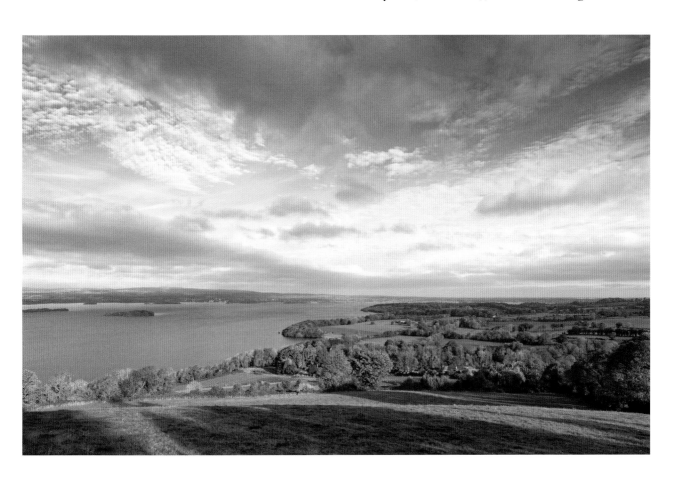

Below: After an absence of over a hundred years White Tailed Sea Eagles returned to Lough Derg in 2011 to breed and successfully managed to raise a chick in 2013. The birds, who were caught as chicks in Norway, had been released at Killarney National Park and had made their way north to settle near Mountshannon at Lough Derg.

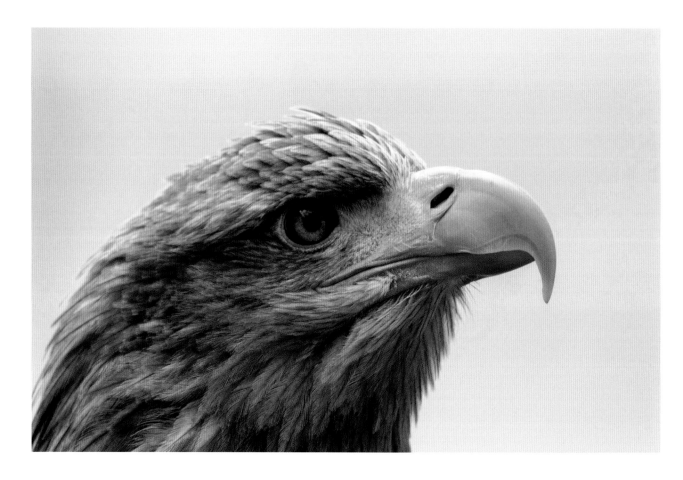

Iniscealtra. This is two small miles about in the Shannon river... called the seven churches of Asia. Here once a year the superstitious Irish go to do penance, and are enjoined to walk around barefooted seven times, and they who fear hurting their feet may hire others to do it for them!

Thomas Dyneley, 1680

One of the most interesting places at Lough Derg lies south of the village of Mountshannon: *Inis Cealtra*, the 'Island of the Burials', also known as Holy Island. The island features the remains of a monastic settlement, founded in the sixth century by St Colum. including a round tower, six churches, high crosses, a holy well and a graveyard with inscribed slabs dating from the eighth century. One headstone features the footprint of the saint that lies buried beneath, another is inscribed with 'The Grave of Ten Men'. The first recorded hermit on the island was MacCriche who according to legend lived in a cell with 'a stone at his back, a stone at each of his sides and a stone at his face.'

Left: The view to Holy Island, Lough Derg, Co. Clare

Below: Holy Island, Lough Derg, Co. Clare

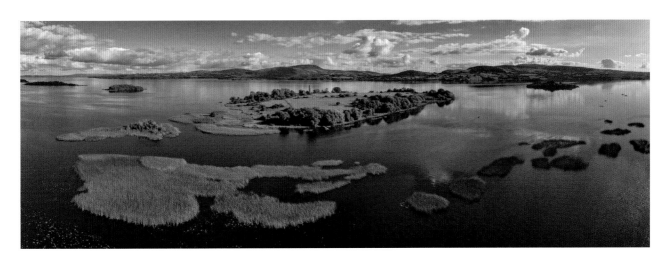

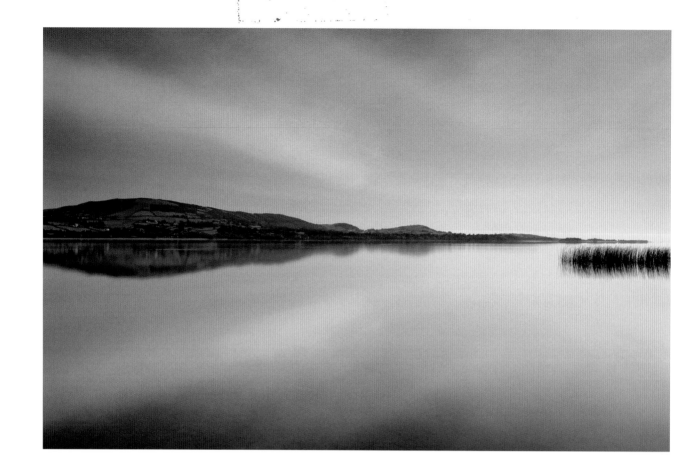

Above: Lough Derg Dawn, near Killaloe, Co. Clare

Opposite top: Rinnaman Point, Lough Derg, Co. Clare

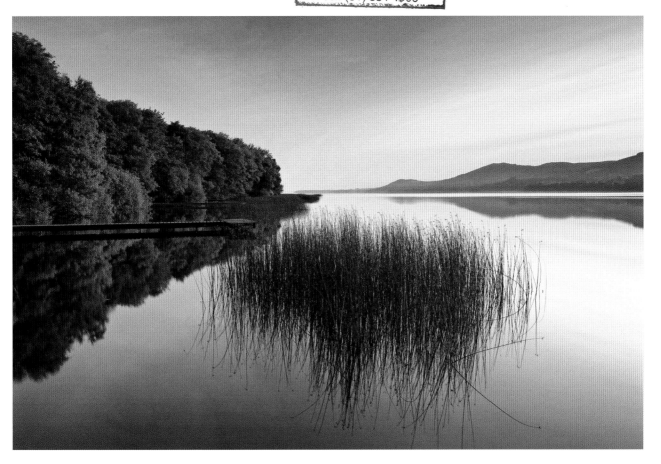

Killaloe, a post-town and parish, containing 8587 inhabitants, of which number 1411 are in the town. This place, anciently called Laonia, derived its present name, supposed to he a corruption of Kill-da-Lua, from the foundation of an abbey, in the 6th century, by St. Lua or Molua. The town is pleasantly situated on a rising ground on the western bank of the Shannon, near the noted falls of Killaloe, and about a mile from Lough Derg, and is connected with the county of Tipperary by an ancient bridge of nineteen arches. Above and below the bridge there are numerous eel weirs, which produce a strong current in the river, and there is also a salmon fishery. Below the bridge the navigation of the Shannon is interrupted by a ridge of rocks, over which the water rushes with great noise; and the appearance of the town at this place, with the waters of Lough Derg in the distance, and its venerable cathedral rising above the bridge and backed by a fine mountain range, is strikingly romantic. Ballina, a village, containing 832 inhabitants. This place is situated on the road from Killaloe to Newport, and on the river Shannon, over which is a bridge of nineteen arches connecting it with the town of Killaloe, in the county of Clare. It contains about 110 houses.

From 'A topographical dictionary of Ireland', 1837

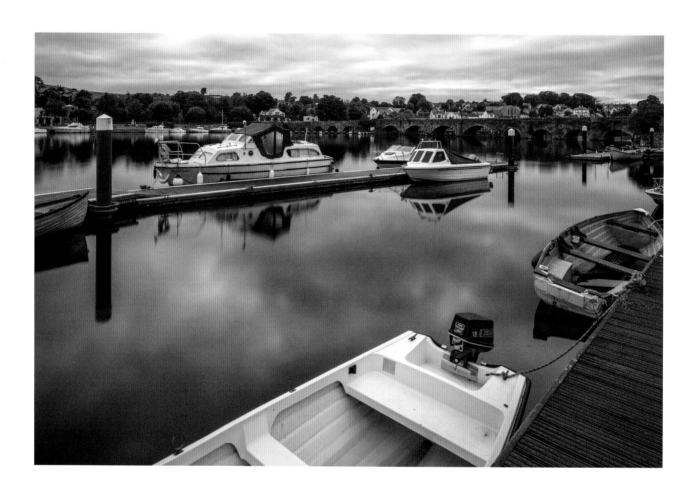

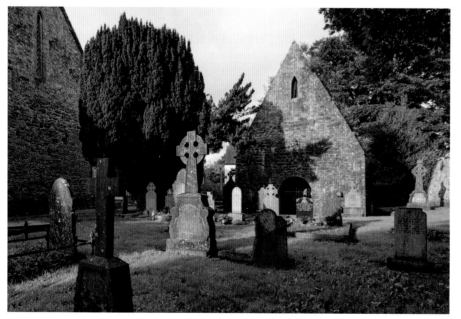

Above: Killaloe/Ballina
Harbour, Co. Clare/Co.
Tipperary
Left: St. Molua's Church,
Killaloe, Co. Clare

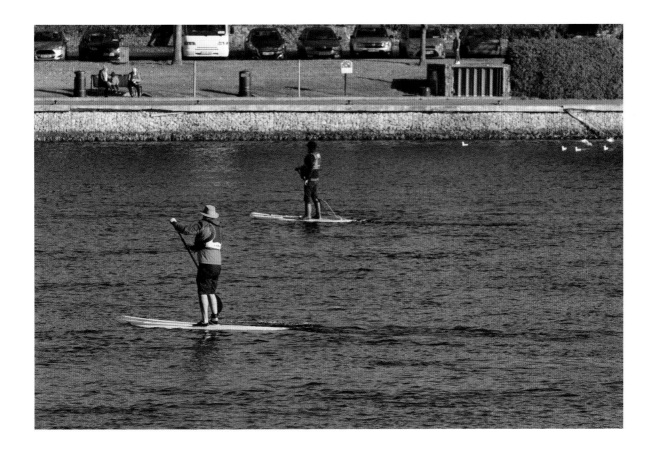

Above: Stand Up Paddle Boarders,
Killaloe, Co. Clare

Right: 'Crepes & Falafels'. Farmer's Market,
Killaloe, Co. Clare

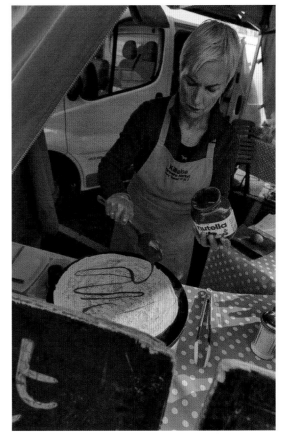

On 13 August 1925 the first sod was cut at Ardnacrusha for what would be the most important undertaking to secure a safe and permanent power supply for Ireland: the Shannon Hydro-Electric Scheme. This was a massive undertaking for a state that was barely three years old. At its peak the project employed over 5,000 people; it cost 20 per cent of the government's revenue budget in 1925.

At Parteen, water was diverted from the main flow of the river Shannon via a dam and intake weir and channelled through a 13km headrace canal to Ardnacrusha where a turbine hall and power station were built.

The scheme was officially opened on 29 July 1929 and at that time it was the largest hydroelectric station in the world.

Below: Parteen Weir and River Shannon, Co. Clare

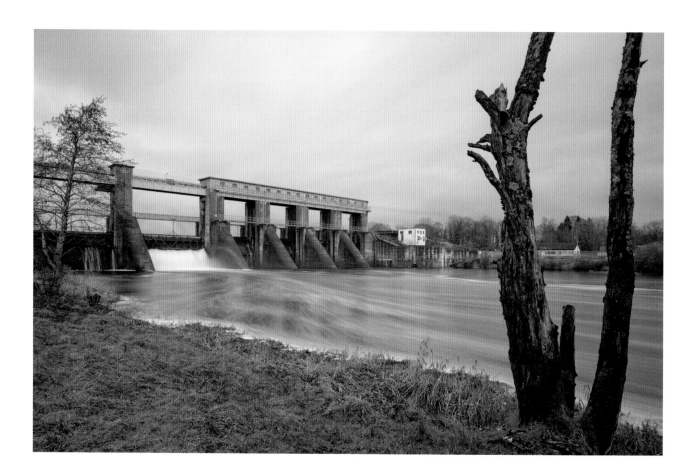

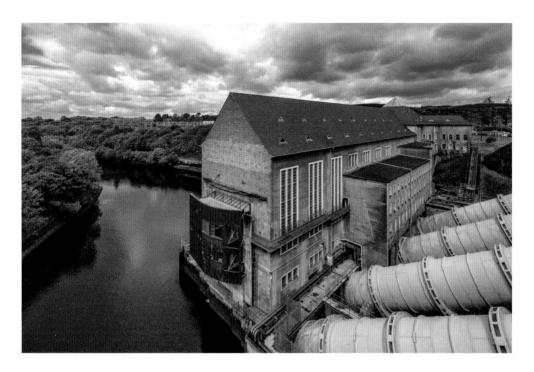

Left: Ardnacrusha Power Station, Co. Clare

Below: Inside Ardnacrusha Power Station, Co. Clare

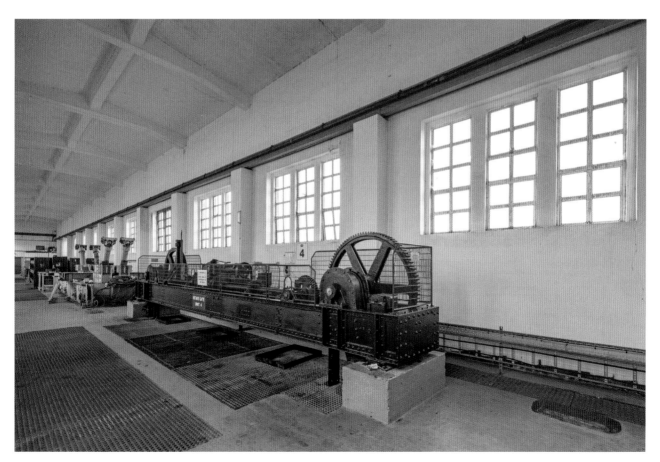

The river was charming, beautiful, calm and it seemed to be deep...

Chevalier De Latocnaye, 1797

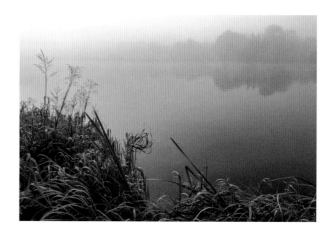

Top left: The Old Limerick Road, near O'Briensbridge, Co. Clare

Top right: Boats on the Shannon near O'Briensbridge, Co. Clare

Above left: O'Briensbridge, Co. Clare

Above right: The Shannon near O'Briensbridge, Co. Clare

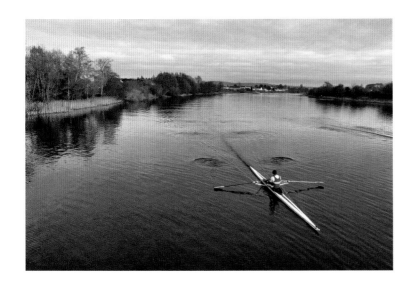

Left: Rowers on the Shannon, O'Briensbridge, Co. Clare
Middle: Doonas Church, Co. Limerick
Bottom: The Shannon near Castleconnell, Co. Limerick
Overleaf top: The Shannon at Castleconnell, Co. Limerick
Overleaf bottom: Shannon Footbridge, Castleconnell, Co. Limerick

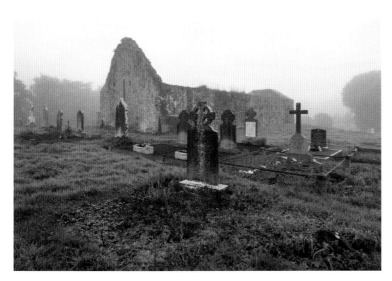

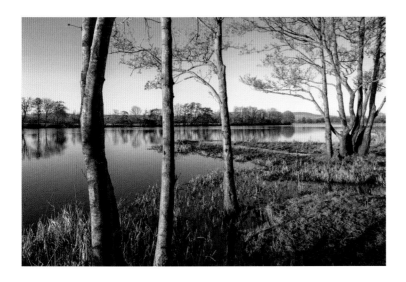

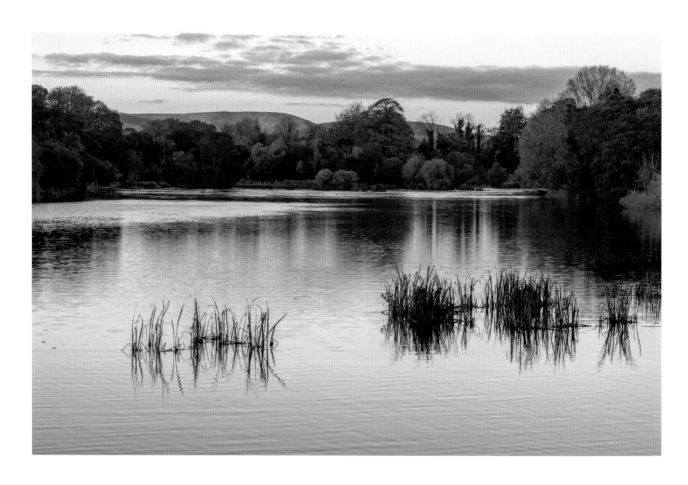

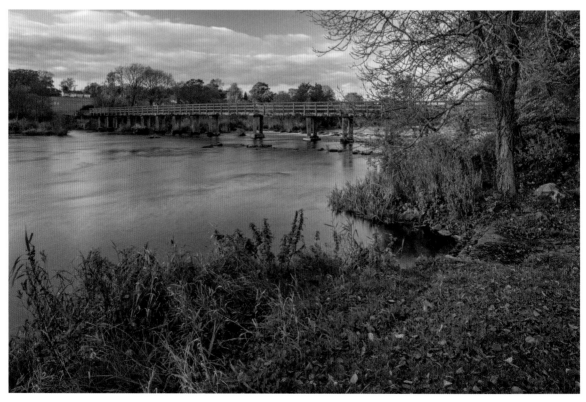

The memory of Limerick that I, and I suppose everyone, takes away is that of a fine bridge

over the Shannon which at this point is a wide and splendid river.

H.V. Morton, from 'In Search of Ireland', 1930

Limerick's origins are lost in time, but it is certain that the first settlement happened on what is today known as King's Island between the rivers Shannon and Abbey. Worked flint that dates back some 6,000 years has been found in the riverbed and Ptolemy's map of Ireland from the year 150 shows a place called 'Regia' at the same site as King's Island.

The foundations of the Limerick we see today date most likely back to the arrival of the Vikings in the second half of the ninth century, but it's safe to say that some kind of permanent settlement already existed when the Vikings arrived for their first raiding party. Historical records suggest that a Dane named Yorus established a fort on or near King's Island in 861. Over time the Vikings turned from raiders to traders and Limerick from a temporary settlement into a centre for trade. A silver penny forged in London and dating from 1035 was found during excavations in the Abbey River and proves the wide-ranging trade of the Vikings.

In 1175 the Anglo-Normans launched an assault on the city and brought the reign of the Vikings to an end. Over the following centuries the new rulers redesigned Limerick to their liking and added many of today's landmarks like King John's Castle and St Mary's Cathedral to the skyline of the city.

In the sixteenth century Limerick was known as the most beautiful city in Ireland and played a crucial role in the Williamite War of the seventeenth century: the Treaty of Limerick ended this war and offered full legal rights to Catholics. Reputedly the treaty was signed on a block of limestone which became known as the Treaty Stone; many implications of the treaty were never signed into law by the Protestant government and in the end had little impact on Irish history.

After the end of the Williamite War Limerick prospered and grew. Its docks became one of Ireland's major trading ports exporting mainly agricultural produce to Britain and America.

During the late nineteenth and early twentieth centuries the Great Famine and the decline of traditional industries left their mark on Limerick. After a period of struggle the city reinvented itself not least with the establishment of the NIHE (National Institute for Higher Education) which became the University of Limerick. Today Limerick is among the four biggest cities on the island of Ireland and a thriving centre for industry, tourism and education.

Right: King John's Castle and the Shannon, Limerick
Below: Thomond Bridge, Limerick

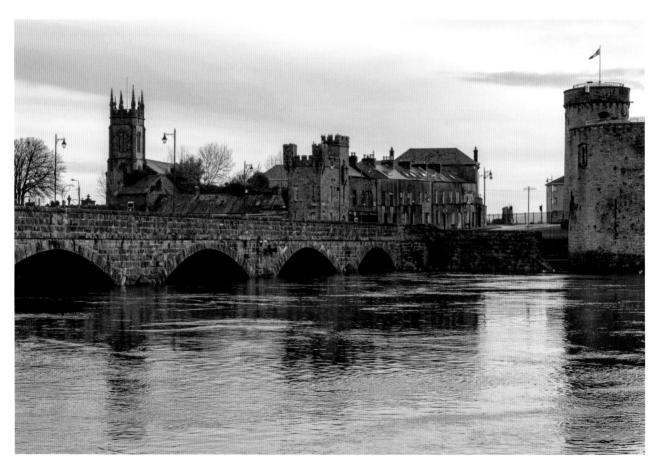

Left: King John's Castle Doors, Limerick
Below: Sarsfield Bridge, Limerick

Bottom: The Treaty Stone, Limerick

Right: Flying kayaks at the Riverfest, Limerick

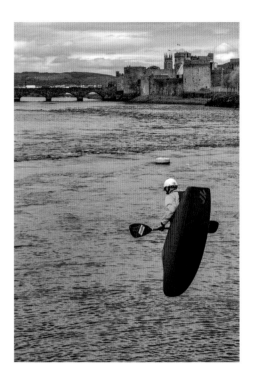

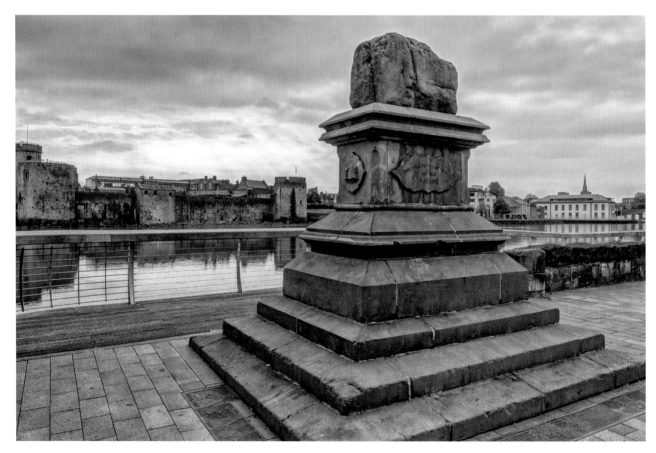

Seán an Scuab was a humble brush maker who lived in a small village outside the city of Limerick. Once a week he would journey into the city across Thomond Bridge to sell his brushes. At the time the leading citizens of Limerick were arguing about who would became the new mayor. This had been going on for weeks and they just couldn't agree. Eventually it was decided that the first person to cross the Thomond Bridge on the following morning would be the man for the job. The next morning just before sunrise in wanders Seán with his brushes. The members of the Council rushed up to him with congratulations and poor Seán took a while to understand what was going on. The rest of the day was spent in celebration and Seán understandably forgot about his brushes and wife back home.

His wife grew worried. So the following day she headed for the city where she met a large crowd who told her of the new mayor and the ongoing celebrations. When she saw Seán hoisted on a chair being led through the streets, she rushed up to him asking if he still remembered her. Seán, still confused from all that had been happening, replied: 'How could I? I don't even know myself.'

Below: Loughrea, Co. Galway

Between the estuary of the river Fergus and the Burren to the west and Lough Derg to the east some forty lakes form the East Clare and South Galway Lakelands. This picturesque area is best known for its fishing, with pike, bream, roach, rudd and other species in plentiful supply.

Right: Lough Graney, Co. Clare

Bottom: Lough Graney, Co. Clare

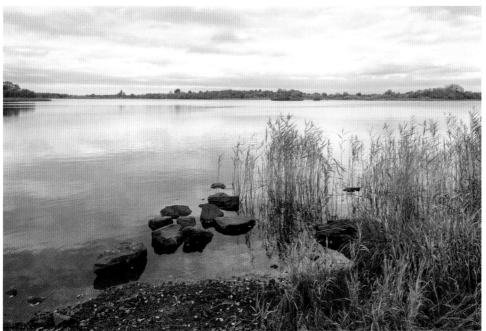

Above: Lough Bridget, Co. Clare
Left: Doon Lough, Co. Clare

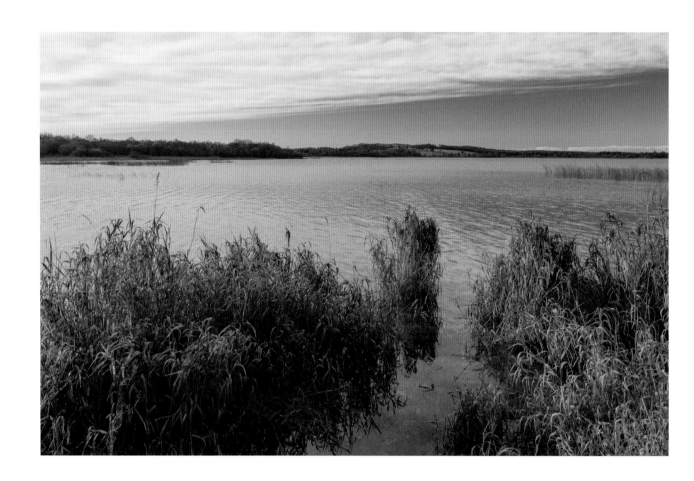

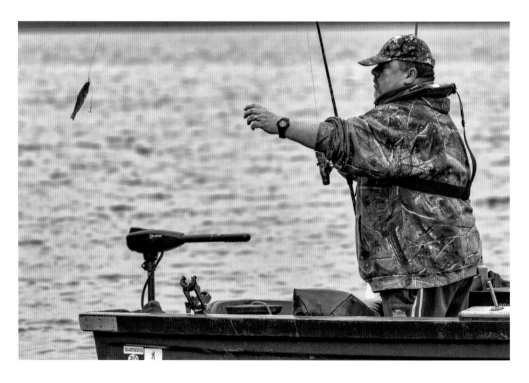

Killone Abbey stands on the shores of the lake with which it shares its name, close to Ennis and the Feargus Estuary. The abbey, one of the few nunneries in the area, was founded in 1190. It's on the grounds of Newhall House, which belonged to the O'Briens, a wealthy family related to the Kings of Thomond and Munster. The last of the O'Briens of Newhall is said to have been a cruel man only concerned with himself and increasing his fortune. One of his most valued possessions was an extensive wine cellar that contained some rare vintages. It is said the cellar was connected to the lake by an underground stream. One day O'Brien noticed that bottles went missing and he decided to catch the thief himself. He wrapped up warm, sat down and waited, ready to confront and catch the thief. Shortly after midnight he noticed movement at the far end of the cellar where the stream entered the cellar. O'Brien rushed towards the intruder, gun in hand. He found himself confronted with a beautiful woman – of sorts. Her upper body was human, but from the waist down she looked like a fish. O'Brien fired the gun and wounded the mermaid badly.

Hurt and bleeding the mermaid screamed out a curse: '*Fish without flesh, meat without bones, hear the mermaid's curse on the plains of Killone. As the mermaid floats bloodless down the stream, so shall the O'Briens pass away from Killone.*'

The wounded mermaid floated back to the lake, which turned red with her blood; it is said that the lake still turns red every seven years. The curse, of course, came true and O'Brien passed away without a male heir.

Opposite Top: Lough Cullaunyheeda, Co. Clare
Opposite Bottom: Fisherman, Doon Lough, Co. Clare
Bottom: Killone Abbey, Co. Clare

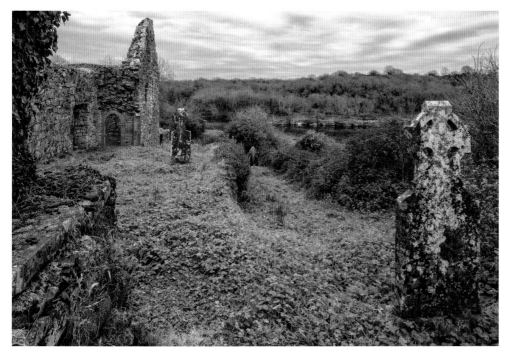

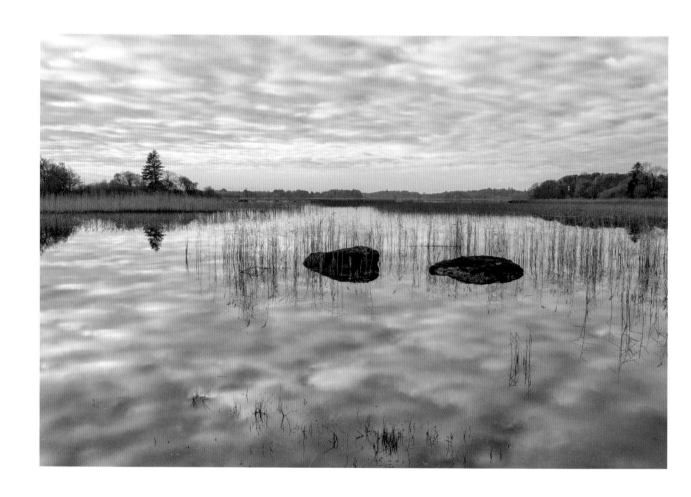

Above: Lough Cutra, Co. Galway
Right: Lough Cutra Castle, Co. Galway

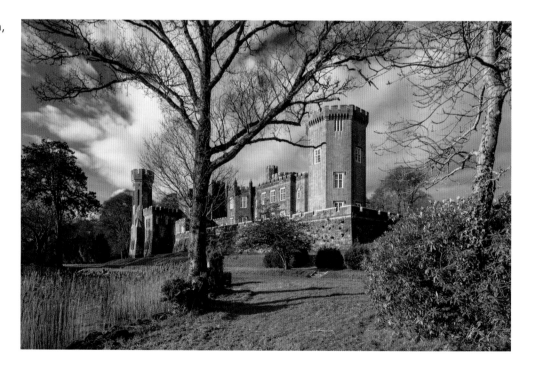

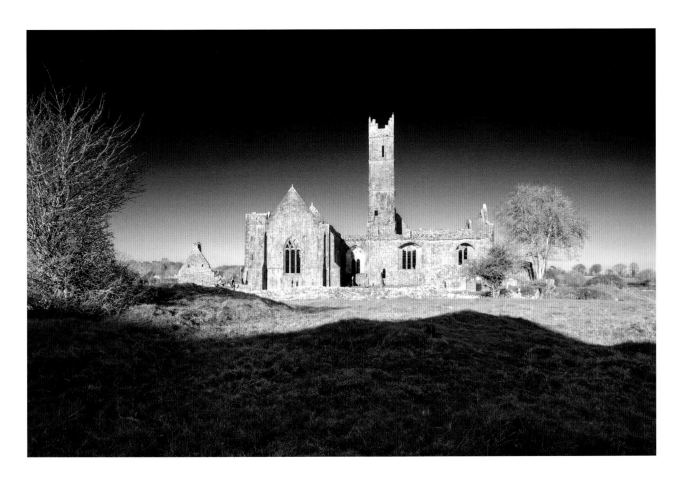

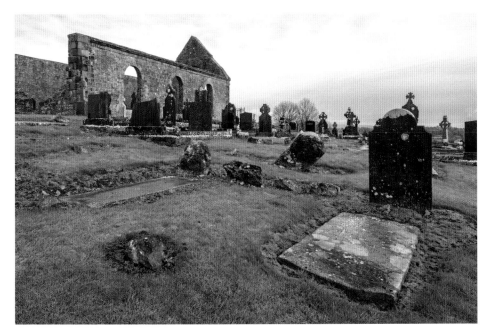

Above: Quin Abbey,
Co. Clare
Left: Tulla Church,
Co. Clare

The Burren is a world renowned limestone karst landscape that cover parts of Co. Clare and Galway. A string of lakes, turloughs and fens forms the eastern border of the region, which otherwise has little or no permanent surface water.

Right: Dromore Nature Reserve, Co. Clare
Below: Muckanagh Lough, Co. Clare

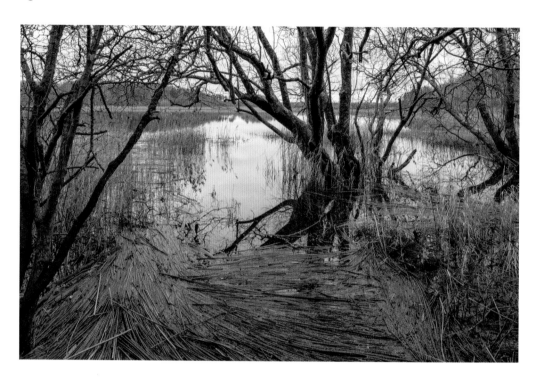

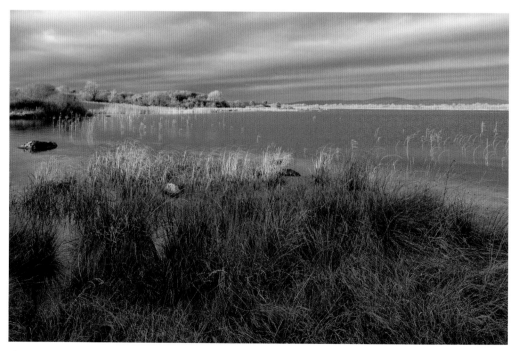

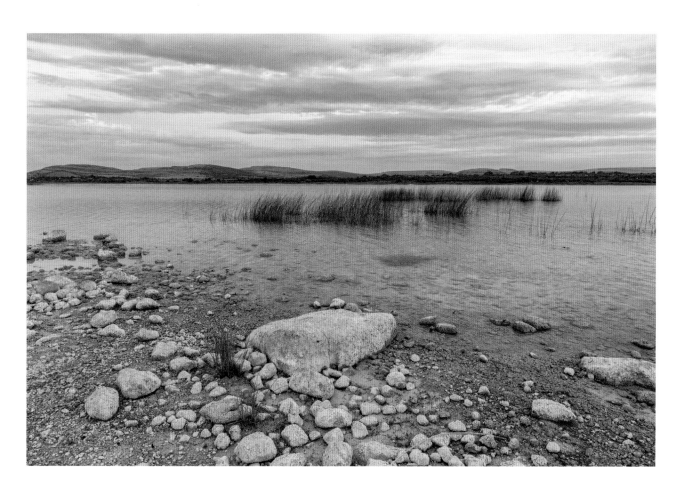

Once upon a time a castle stood where today Lough Inchiquin lies. Each morning Lord Inchiquin, the master of the castle and surrounding lands, would go to the well to have a drink. One morning he saw a beautiful woman standing close to the well. Lord Inchiquin fell head over heels in love and asked the woman to marry him. The woman told him she couldn't because she wasn't of his world, she was a fairy. Lord Inchiquin went home heartbroken. The next morning the woman again was standing close to the well. Lord Inchiquin asked her again to marry him and this time she agreed. Only a few days later they were married. They had two children and lived happily for a time.

The lord loved his family, but he also loved hunting. One day his wife asked him to come home alone

Above: Lough Bunny, Co. Clare

after the hunt and sent his hunting party elsewhere. To please his wife Lord Inchiquin did so. Next day she asked him the same thing, but this time the lord feared he would lose the respect of his hunting party and brought them home to entertain them. When his wife saw him entering the castle with his friends she thought he didn't love her anymore and so she took their two children and returned to the fairy world. Before she left however, in her pain and anger, she cast a spell over the well where she and her husband had meet for the first time. The water in the well begun to rise covering all the land and the castle. It is said that on a calm day the castle can still be seen beneath the waters of Lough Inchiquin.

Below: Lough Inchiquin, Co. Clare
Right: Ice on Fin Lough, Co. Clare

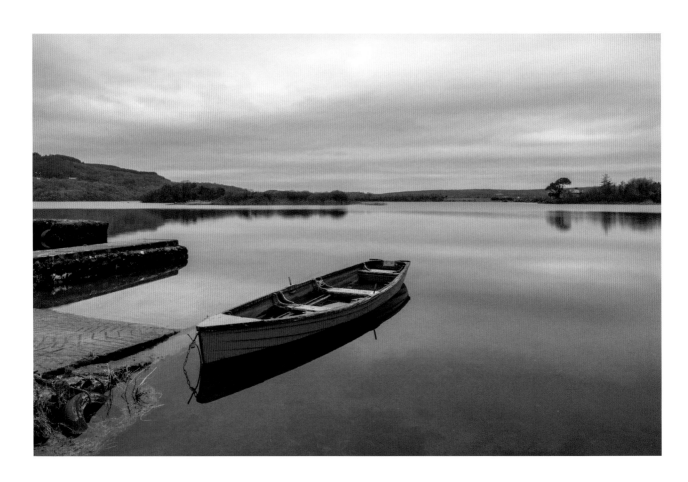

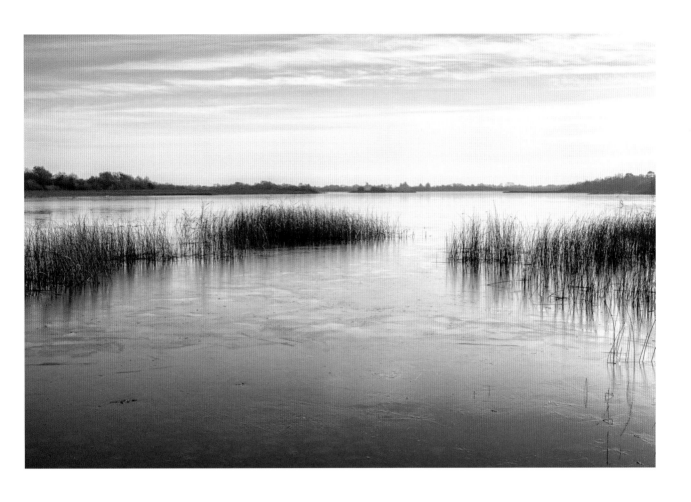

.. you can have a pleasant and leisurely holiday here, in a region unknown to the tourist,

but possessing much quiet beauty and all that goes with the unspoilt Irish countryside.

Robert L. Praeger, from 'The way that I went', 1937

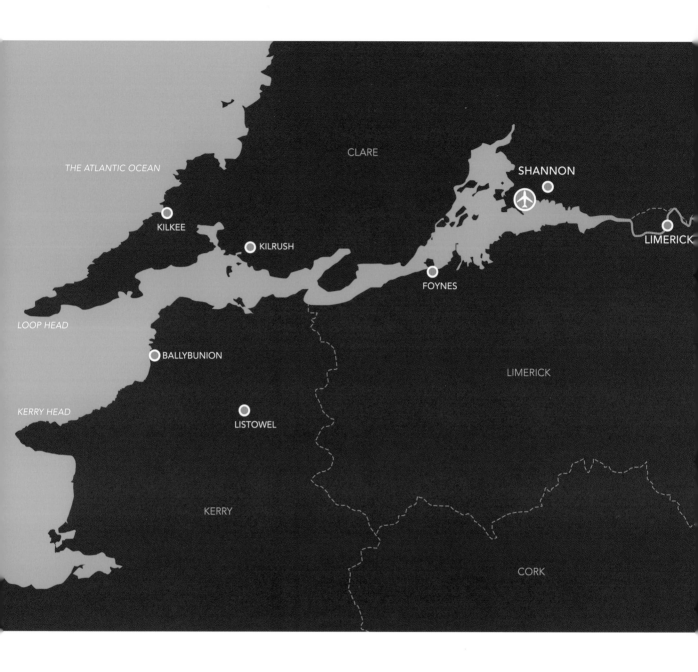

THE ATLANTIC OCEAN

CLARE

SHANNON

LIMERICK

KILKEE

KILRUSH

FOYNES

LOOP HEAD

BALLYBUNION

LIMERICK

KERRY HEAD

LISTOWEL

KERRY

CORK

CHAPTER 3:

THE SHANNON ESTUARY

At Limerick City the Shannon becomes tidal. Further west, the river widens considerably and opens up into a wide estuary that stretches on for almost 100km. Along the way a number of rivers join the Shannon. Among them is the Maigue, which enters the estuary from the south and directly opposite the Owenagarney or Ratty River at Bunratty. The Deel River joins at Askeaton, the Glencorbly at Glin and the Crompaun and Cloon River enter at Clonderalaw Bay. The Fergus, which joins the Shannon south of Ennis town, forms an extensive, island-dotted estuary itself and joins the main channel of the Shannon between Kildysart and Shannon Airport.

For many centuries the Shannon Estuary, or to be technically correct the Shannon-Fergus-Estuarine-Complex, has been one of the main access routes into Ireland for travellers, traders and invaders. The number of castles, batteries and lookout posts speak for the strategic importance of the estuary throughout the centuries. The estuary's first historic appearance dates back to the first century when the Greco-Egyptian mathematician, astronomer, astrologer and geographer Claudius Ptolemy included it into his world map. Since then the Shannon Estuary has seen the coming and going of countless vessels: merchant ships brought goods from all over the world to the once mega port in Limerick and left again with emigrants on board. In the early nineteenth century turf boats, military and steam boats were also a regular sight. *The Lady of the Shannon* was one of the latter and made regular sailings from Limerick City to the town of Kilrush. This heavy traffic gave rise to the Shannon Pilots, which were licensed in 1823. This part time profession soon became a family tradition of families based in Carrigaholt, Kilbaha and on Scattery Island.

Another by-product of the shipping traffic was piracy. A newspaper report from 12 December

1831 reads like this:

The Henrietta sloop, of Ballylongford, was boarded last Friday morning, in the mouth of the Adare River on her passage home from Limerick, by six men, armed and with their faces painted, who ordered all the passengers up on deck, and rifled the persons of every one of them, carrying off a good booty. While engaged in this daring outrage, the ruffians presented fire arms at the heads of their victims, threatening instant death in the event of resistance. They also went below and searched the cargo, consisting of groceries, woollens and mercery, and plundered a bale of silk handkerchiefs, muslins, laces, and shawls.

On the same night a sail-boat belonging to Knock, County Clare, was also plundered by a party of ruffians, who boarded her in the Shannon.

Boats were not only attacked on the water: small ports were sometimes attacked from land and wreckers lured ships onto rocks with lanterns.

Today, shipping traffic consists mainly of the car ferry that connects Killimer with Tarbert, and large cargo ships. In summer, dolphinwatch boats launch from Kilrush and Carrigaholt and a number of pleasure craft enjoy the calm days on the water.

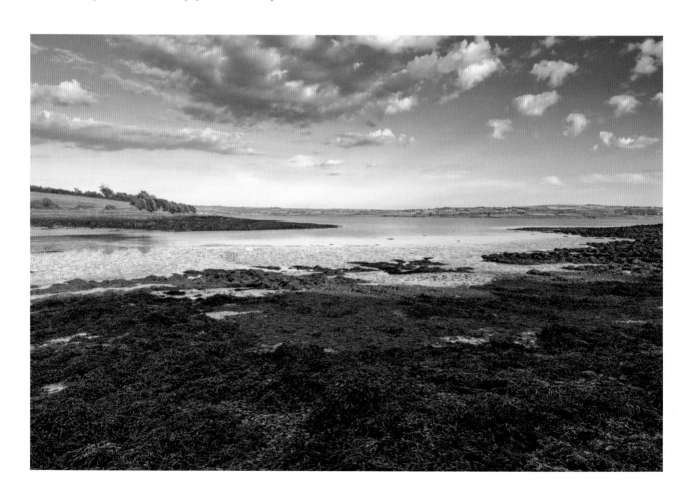

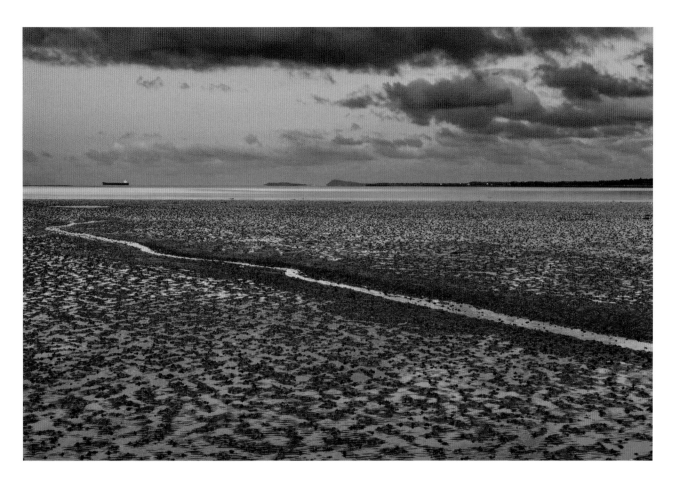

Above: Baurnahard Point, Co. Clare

Opposite: Labasheeda Harbour, Co. Clare

This doesn't mean the Shannon Estuary has lost its importance: Foynes is one of the main trading ports in Ireland, the power stations at Tarbert and Moneypoint have produced electricity for the west of Ireland for decades, the alumina refinery at Aughinish is the largest in Europe and the airport at Shannon is a main hub for national and international flights. But it's not only big industry that thrives at the estuary: a number of small fishing ports still operate and tourism is a major lifeline for the towns and villages along the estuary.

The importance of the estuary, however, goes far beyond industry: it's a sanctuary for resident and passing wildlife. Wildfowl and waders find shelter in the many bays of the estuary; guillemots, razorbills, kittiwakes, fulmars, choughs and other birds nest at the cliffs, and gannets visit the waters of the estuary to feed. Common and Grey Seals call the estuary their home as does Ireland's only resident group of Bottlenose Dolphins, which are locally known as the Shannon Dolphins.

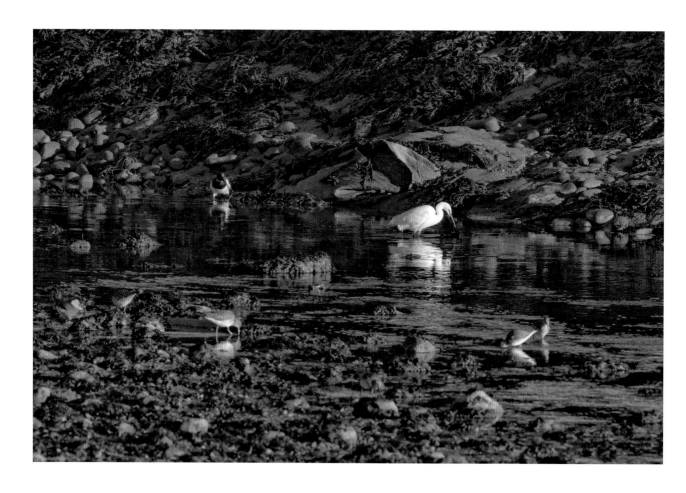

Above: Feeding time at Querrin Pier, Co. Clare: Little Egret, Oystercatcher and Redshanks
Left: Old Pier, Glin, Co. Limerick

Askeaton lies on the River Deel in Co. Limerick, which enters the Shannon Estuary only a few kilometres north of Askeaton. The town is one of the oldest in Co. Limerick and has a long and eventful history. The castle, which was built on an island in the centre of the town, dates back to 1199. It was built by William de Burgo, but changed owners a number of times before it became residence for the Earls of Desmond, one of the main ruling families in Munster, in 1348. The castle was dismantled in 1652 during the Cromwellian invasion.

The Franciscan Friary is said to have been founded in 1389 by Gerald Fitzgerald, 3rd Earl of Desmond. According to legend, the 3rd Earl – also known as Gerald the Poet – is resting in a cave near Lough Gur waiting to rise and rule again.

In 1579 the nearby castle of Askeaton was under siege by English troops under the command of Sir Nicholas Malby. Failing to take the castle Malby burned down the town and friary. The monks returned in 1627 and slowly rebuilt the community. In 1740 the friary was abandoned for good.

Below: Askeaton Friary, Co. Limerick

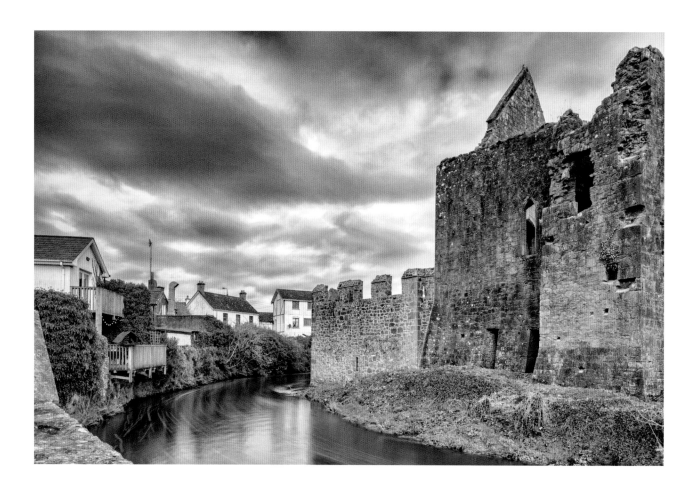

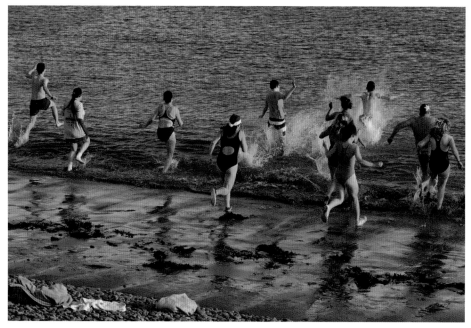

Above: Askeaton Castle and River Deel, Co. Limerick

Left: Christmas Day swim, Carrigaholt, Co. Clare

Foynes is a small village on the southern shores of the Shannon Estuary. Foynes Harbour was first surveyed in 1837 as a potential port to take pressure off the busy Limerick Docks. Work started in 1846 and today Foynes is the second largest port in Ireland and continues to grow.

Foynes itself doesn't seem very different to other Irish villages, however, it has seen and made a good bit of history as an international port for arrivals from sea and air.

For a short period in the late 1930s and early 1940s the village of Foynes became one of the biggest civilian airports in Europe. At the time, flying boats were the preferred option to carry passengers and freight across the Atlantic Ocean and in 1935 the governments of the USA, UK, Canada and the Irish Free State agreed that all transatlantic aircraft would stopover in Foynes. Those flying boats were nothing like our modern airliners. They were much slower and could only operate at low altitudes, but were the only aircraft to be able to cross the Atlantic Ocean and did so in style. Spacious en suite cabins, a dining room and freshly prepared food meant travel in luxury. Over the following years Foynes saw many of the rich and famous passing through including Ernest Hemingway, John F. Kennedy, Humphrey Bogart and many others.

During World War II, Foynes (although Ireland remained a neutral country) became the port of call for many refugees escaping wartorn Europe for a new lives in America. Military personnel also passed through Foynes in civilian clothing, which allegedly led to the joke among those who worked at Foynes, 'Who are we neutral against?'

After WWII rapid developments in aviation resulted in the first airliners as we know them today and the flying boats became obsolete. In October 1945 the last flying boat left Foynes under Captain Charles Blair who returned a few days later with a commercial flight into Rineanna, which today is known as Shannon Airport.

Bottom left: Flying Boat in Foynes at its heyday, Co. Limerick
(Photograph copyright Foynes Flying Boat & Maritime Museum)
Bottom right: Interior of the 'Yankee Clipper', Foynes Flying Boat Museum

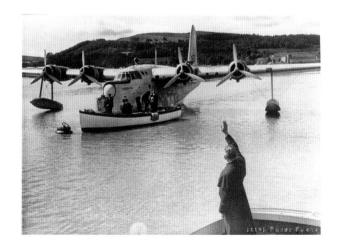

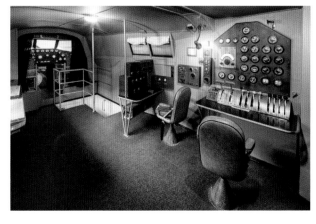

Left: Alumina refinery, Aughinish Island, Co. Limerick

Below: Unloading of a freighter, Foynes Port, Co. Limerick

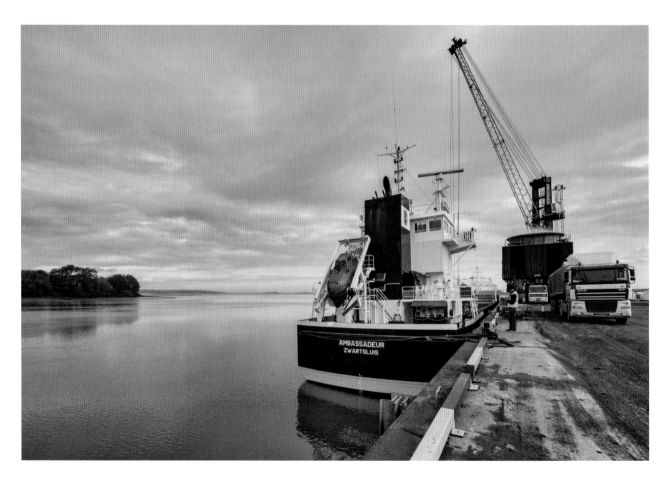

After the demise of the flying boats and with it Foynes Airport the Irish Government started to develop an airport at Rineanna on the northern shores of the estuary. Shannon Airport started operation in 1945 and soon became known as a gateway between Europe and the Americas and one of the three main Irish airports beside Dublin and Cork. In the 1950s the first airport duty free liquor shop was opened and in the 1960s a new runway was built to accommodate long range jet aircraft. During the construction of the jet runway a fisherman's cottage was taken down and rebuilt brick by brick near Bunratty Castle. From these humble beginnings grew the Bunratty Folk Park, one of the major tourist attractions in the country. Over the following decades Shannon Airport continued to grow. The 1980s saw the construction of a dedicated fuel farm and painting hangar with refurbishment facilities and new terminals were added in the 1970s and 2000s. Today Shannon Airport serves the UK, Europe and the USA on a daily basis and handles close to 2 million passengers each year.

The town of Shannon was planned and built alongside the airport in the 1960s to house airport workers. Initially the project wasn't overly successful because most employees preferred to settle in proper towns and villages like the nearby Newmarket-on-Fergus and Ennis. Over time however Shannon grew into the second-largest town in Co. Clare.

Below: Shannon Airport and Lagoon, Co. Clare

Left: Ballycorick Creek, Co. Clare

Below: Kilmurry Quay, Co. Clare

Opposite top: Cross, Co. Clare

Opposite bottom: Ennis, Co. Clare

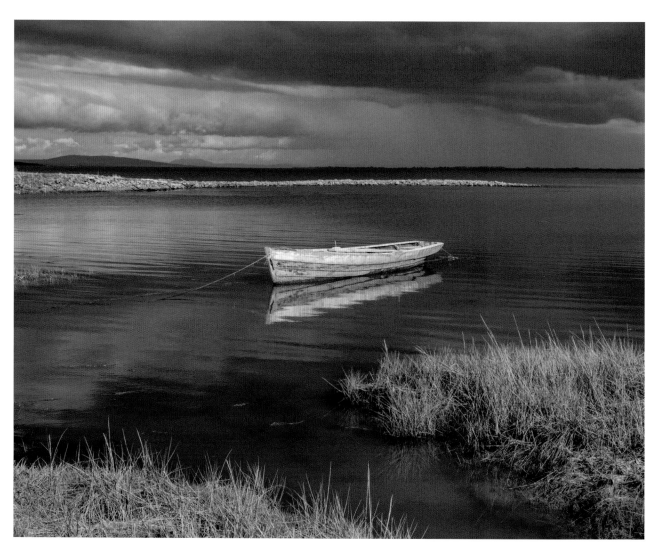

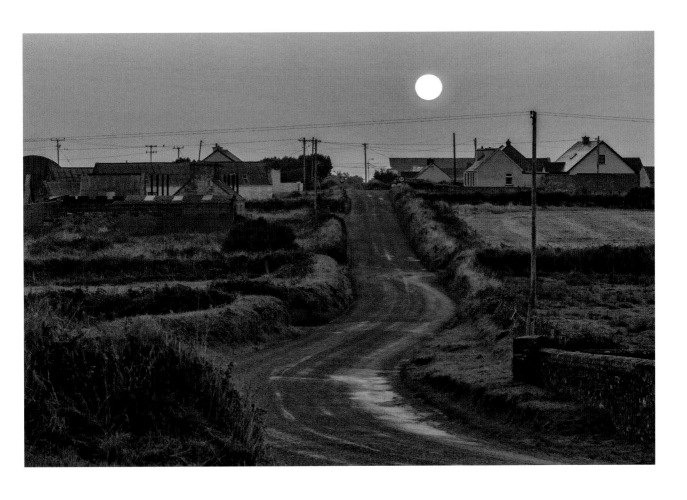

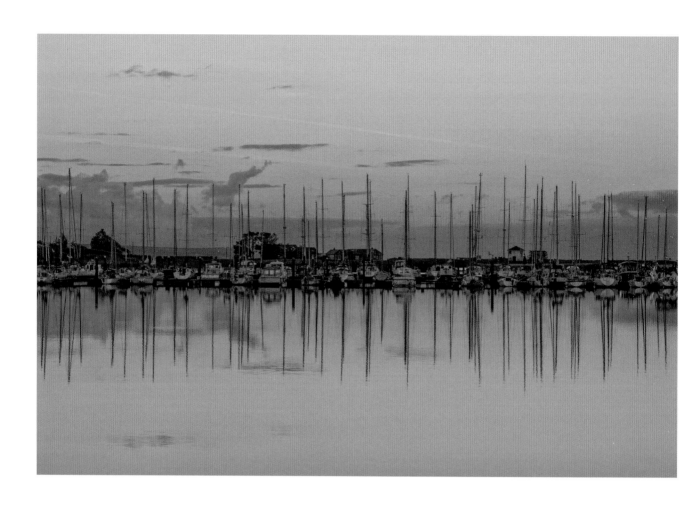

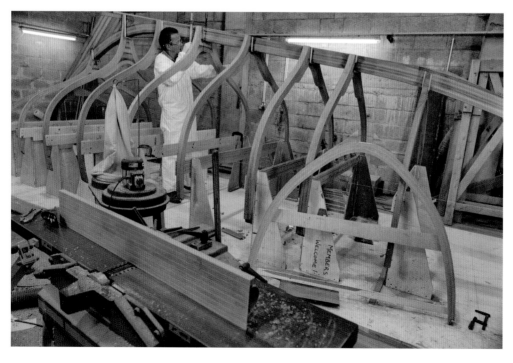

Opposite top: Kilrush Marina, Co. Clare

Opposite bottom: Boatyard, Kilrush Marina, Co. Clare

Right: Cappagh Pier, Co. Clare

Middle: Lifeboat launch at Cappagh, Co. Clare

Bottom: Pilot Curragh, Querrin, Co. Clare

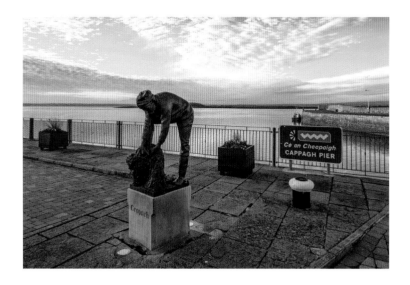

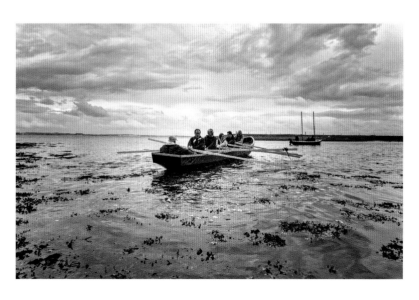

'*In this woman's womb there is a child who will bring the Christ's message to the people of Corca Bascin. He will do many miracles and baptise the people.*' Those were the words of a druid and the child he was talking about was Saint Senan. Countless legends are told about Senan, as a child he parted the waters of the Shannon to bring home the cattle and created a well to drench the thirst of his mother. The best known story however is about his battle with the Cataigh (or Catach), a ferocious sea monster that claimed a small island near Kilrush which is today known as Scattery. The monster was described as an enormous eel with a line of sharp barbs along the back, dagger-like teeth and long enough to curl around the island. Nobody dared to go near the island because the monster devoured everything that came close.

The island came to Saint Senan in a vision after he had travelled around Europe for many years, founding churches and spreading the word of god. The vision was a sign for Senan to return home. Only equipped with a golden cross Senan faced the monster which soon recognised Senan's power and surrendered. It is said that Senan banished Cataigh to Doolough Lake where the creature leads a quiet life only stirring every seven years.

Because there is some truth in every legend it is very likely there really was a sea monster or even many of them. If you look at a group of dolphins travelling with their fins cutting through the water one could indeed imagine an eel-like creature swimming along. If the Bottlenose Dolphins of the Shannon were indeed the inspiration for Cataigh they have been living at the Shannon Estuary for many centuries.

Today over a hundred animals are known to reside permanently at the estuary, taking advantage of the rich food supply brought in by the strong currents. It is not unusual to encounter the Shannon Dolphins while on a walk around Loop Head or Kilcredaun. For those wishing for a close encounter dolphinwatch boats operate during spring and summer from Kilrush and Carrigaholt.

After he had gotten rid of Cataigh Senan was able to build his monastery on Scattery Island. Today the ruins of six churches and a well preserved round tower remind us of Saint Senan's legacy.

Opposite top: Dawn over Scattery Island, Co. Clare
Opposite bottom: Scattery Island Shore, Co. Clare

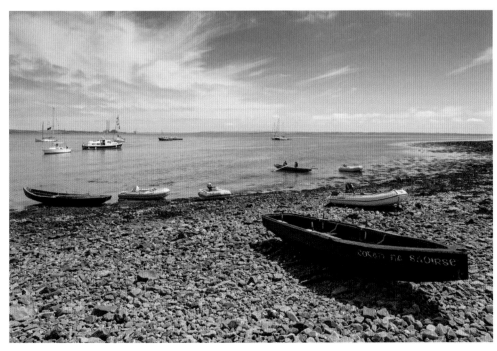

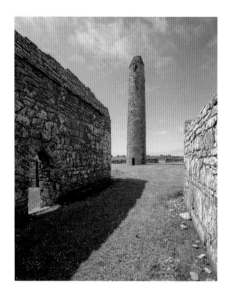

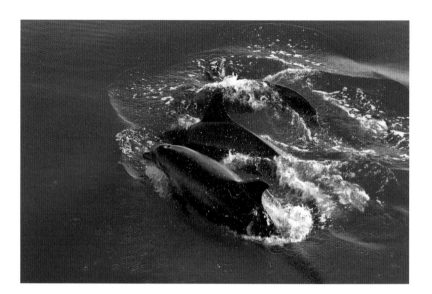

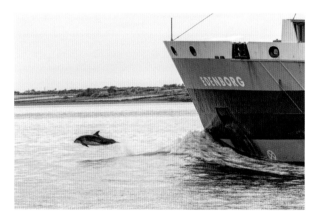

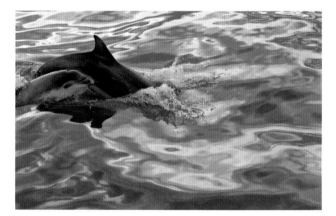

Top left: Church and Round Tower on Scattery Island, Co. Clare

Top right: Bottlenose Dolphins

Above left: Bottlenose Dolphin bow riding

Above right: Bottlenose Dolphins, mother and calf

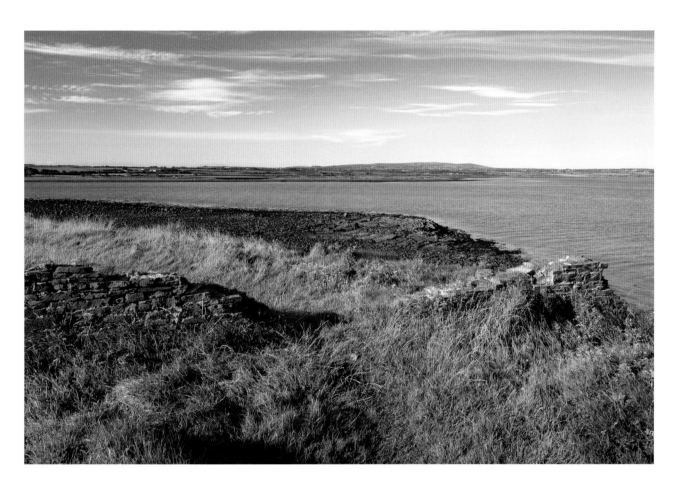

In the early 19th century the British built a vast defence network around the Irish coast in fear of a French invasion led by Napoleon Bonaparte. This network consisted of watchtowers, Martello towers and gun gatteries. The Shannon Estuary was seen as one of the most likely attack points of an invasion fleet and was heavily fortified: five watch towers were built as an early-warning system that would report any concentration of ships. Seven gun gatteries, located at Kilcredaun, Doonaha, and Kilkerrin and on the islands of Scattery, Tarbert, Foynes and Carrig, were strategically placed to catch any intruder in heavy crossfire.

However only a year after all the defences had been completed Napoleon was defeated at Waterloo and the fortifications became obsolete.

Above: View from Carrig Island, Co. Kerry

 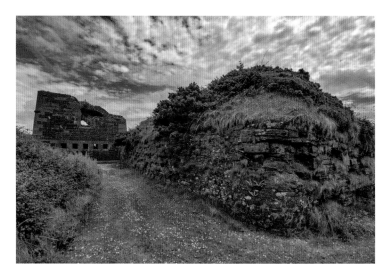

Above left: Battery on Carrig Island, Co. Kerry

Above right: Doonaha Battery, Co. Clare

Below: Kilcredaun Battery, Co. Clare

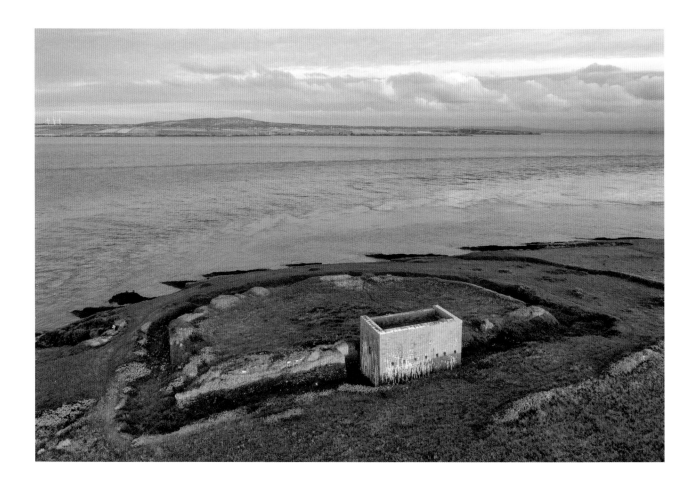

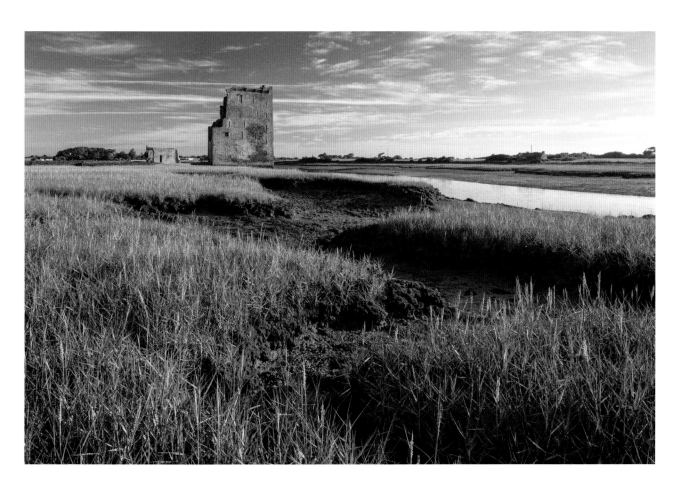

Carrigafoyle Castle can be found close to the town of Ballylongford, overlooking Carrig Island. The castle was built in 1490 in a typical tower-house style by Conor Liath O'Conner-Kerry, rising over five storeys and twenty-six metres from the ground Carrigafolyle had the reputation of being one of the strongest castles in the country.

During the Second Desmond Rebellion (1579-1583) the Siege of Carrigafoyle was the beginning of the end. After a two-day siege and heavy bombardment from land and sea parts of the castle wall collapsed killing many of the defenders. The survivors fled, but most were shot, killed by the sword or hanged. Once word had spread that Carrigafoyle had fallen, other Desmond strongholds, including the one in Askeaton, were abandoned by the rebels.

Above: Carrigafoyle Castle, Co. Kerry

Top left: Lislaughtin Friary, Ballylongford, Co. Kerry

Top right: Killimer, Co. Clare with Tarbert Power Station on the Kerry side of the Shannon

Moneypoint Power Station went on the net in 1987 as Ireland's largest power generation plant. It is capable of meeting 25 per cent of Ireland's electricity demand. Moneypoint is mainly powered by coal, which also makes it one of the biggest emitters of greenhouse gases. The future of the power station is unclear, but the construction of a wind farm that could power around 10,000 households a year beside the plant is a first step into green energy for Moneypoint.

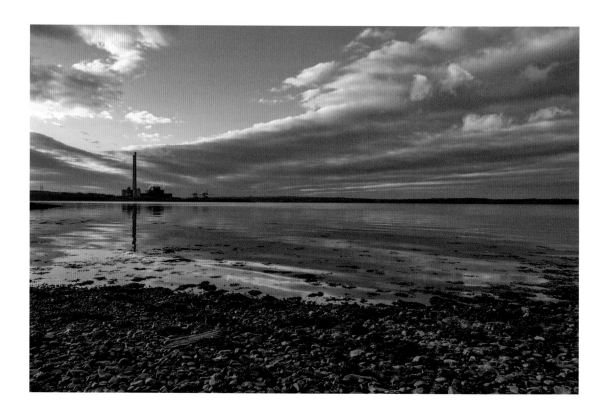

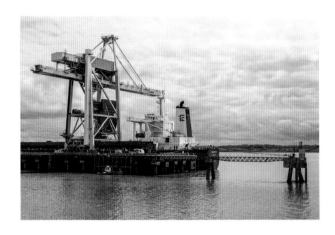

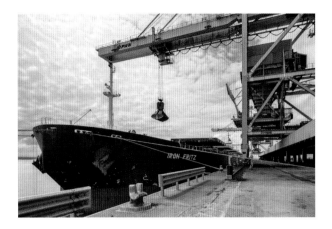

Opposite bottom: Moneypoint Power Station, Co. Clare

Top left: Cargo ship at Moneypoint Pier, Co. Clare

Top right: Unloading of a cargo vessel at Moneypoint, Co. Clare

Bottom: Moneypoint seen from the Loop Head Peninsula, Co. Clare

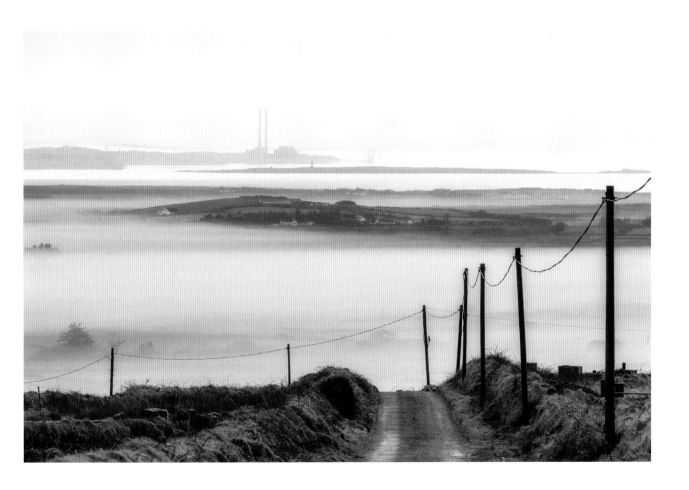

Above: Shore details, Shannon Estuary, Co. Clare

Opposite: Doonaha, Co. Clare

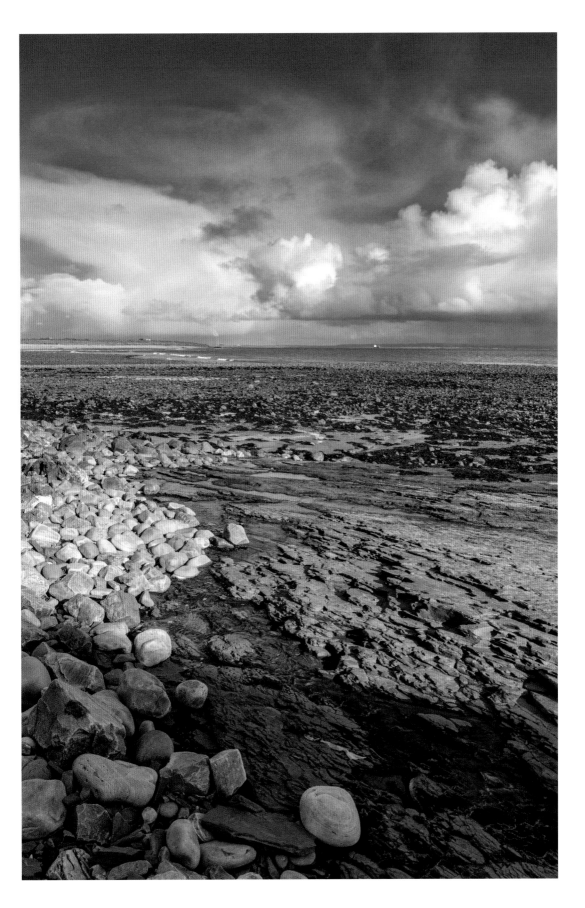

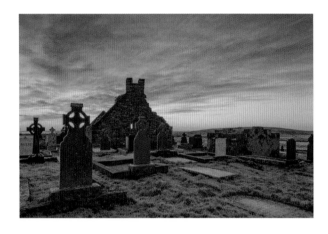
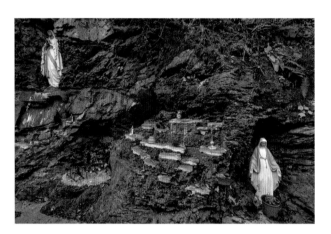

Top left: St Martin's Well, Querrin, Co. Clare

Top right: Kilnagalliagh Graveyard, Co. Clare

Above left: Kilballyowen Church, Co. Clare

Above right: Holy Well, Ballynacally, Co. Clare

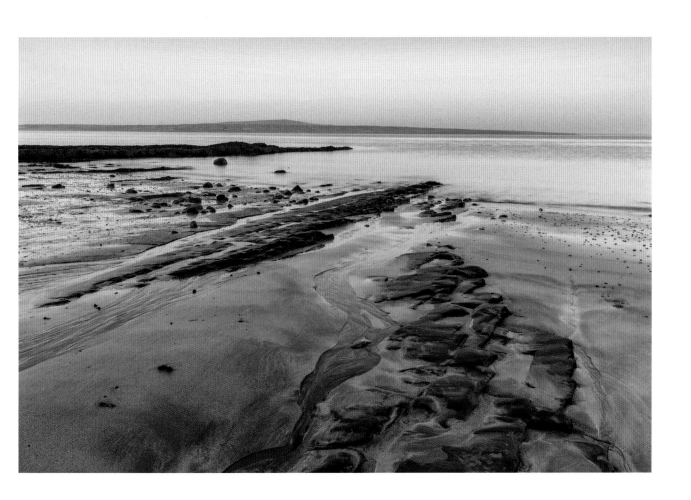

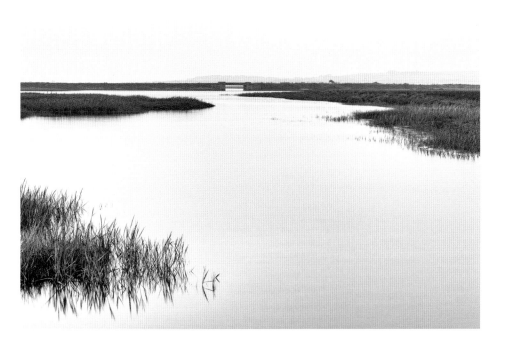

Above: Doonaha
Beach, Co. Clare
Left: Old West Clare
Railway bridge at
Moyasta, Co. Clare

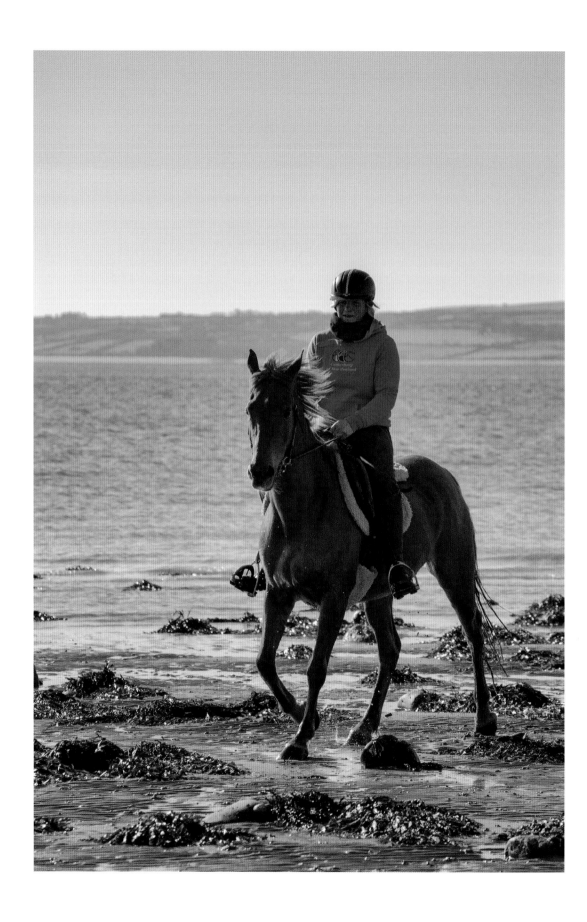

A long time ago a farmer used to grow oats in his field that bordered the shores of the Shannon. One morning he noticed that his oats had been trampled and some had been eaten. After this went on for a few days he decided to spend the night hidden at the edge of the field to find out what was going on. Just after midnight the farmer saw three white horses and one foal coming across the beach as if they had just emerged from the waters of the Shannon. The farmer remembered a story his mother had told him about magical horses living under the Shannon – it was said that if their skin was touched by earth they would have to do the bidding of whoever had thrown the earth. So the farmer scooped up a clod of dirt and threw it at the white foal, which immediately stood still, frozen on the spot. The farmer trained the horse, which grew into a fine mare that worked for him and gave him a white foal a year for seven years. The following spring the farmer and the white mare were ploughing the very field where this story had started when the farmer heard the sound of horses. The mare heard it too, she was neighing loudly, bucking and kicking until she was free of her tack. There was nothing the farmer could do. The white mare ran towards the water where seven white horses stood waiting. Together they all disappeared beneath the waves. It is said that all white horses in Co. Clare descended from that white mare.

Carrigaholt is a small fishing village that spreads out from a central square. Two piers and an imposing fifteenth century castle are located at the outskirts of the village. Kilcredaun headland south of the village features more historic landmarks: an Irish summer college, two early Christian churches, a battery and the wreck of the *Okeanus*, a steamship that ran aground on the rocks off Kilcredaun point in 1947.

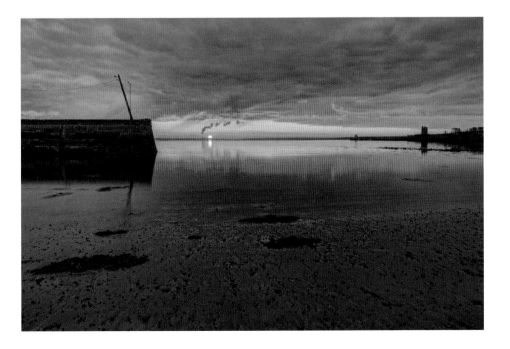

Opposite: Horse riding at the Shannon Estuary, Co. Clare
Left: Carrigaholt Bay, Co. Clare

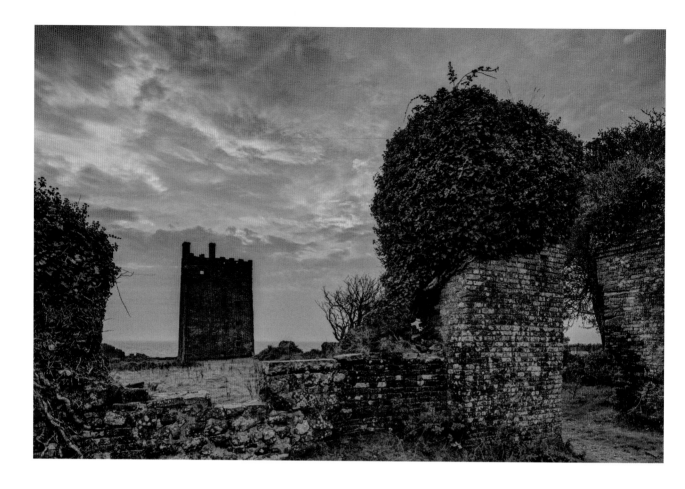

Above: Carrigaholt Castle, Co. Clare

Below left: Carrigaholt, Co. Clare

Below right: Looking west towards Loop Head from Oldtown Co. Clare

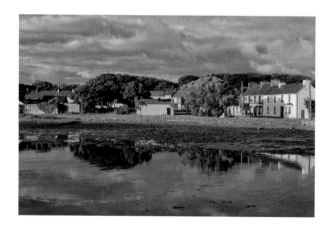

Rinevella is a sheltered bay near Carrigaholt overlooked by Rehy Hill to the west and Kilcredaun with its retired lighthouse to the east. The bay is divided by a narrow headland. While the western part of Rinevella Bay features a wide sandy beach the eastern part has been stripped of all sand with the underlying peat completely exposed. Embedded within the peat are the remains of the vast forests that once covered the area: Trunks and branches of mainly scots pine that have been thriving some 4,000 years ago.

Near the dividing headland the remains of an old stone wall emerge at low tide. It is likely that this wall was a salmon weir that could date back as far as Neolithic times.

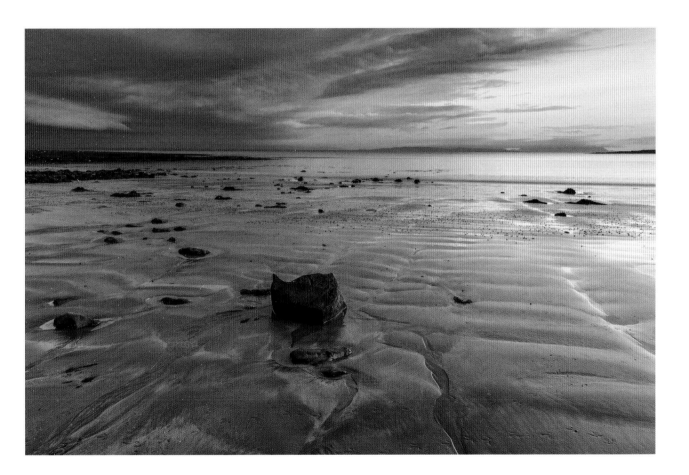

Above: Rinevella Beach, Co. Clare
Overleaf top: Kilcredaun Lighthouse with salmon weir in the foreground, Co. Clare
Overleaf bottom: Rinevella Drowned Forest, Co. Clare

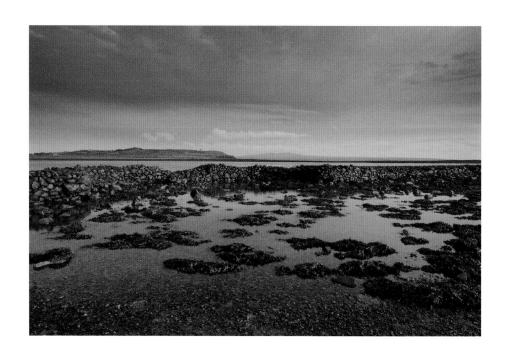

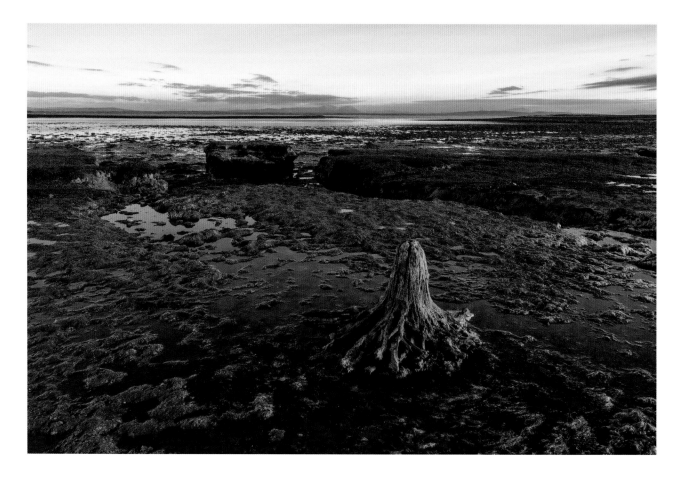

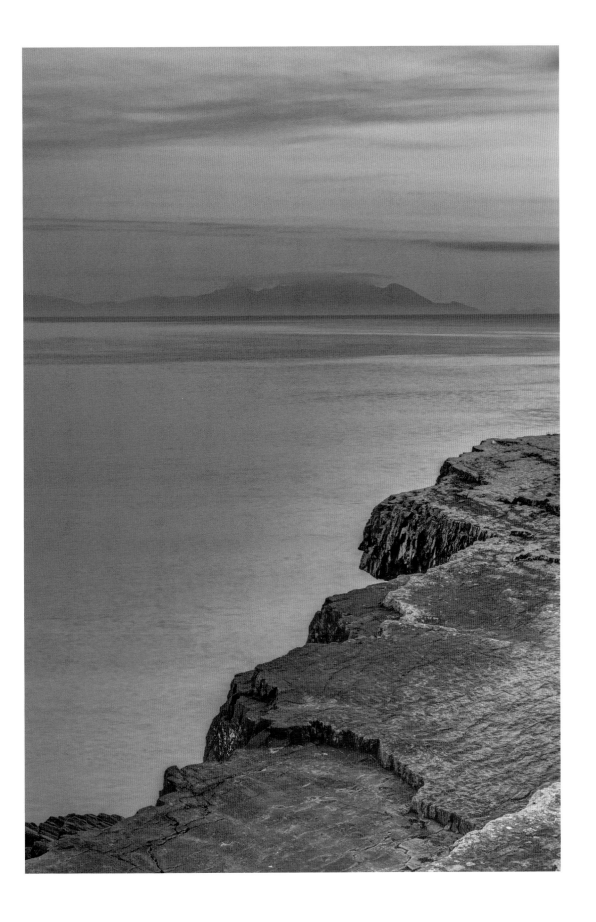

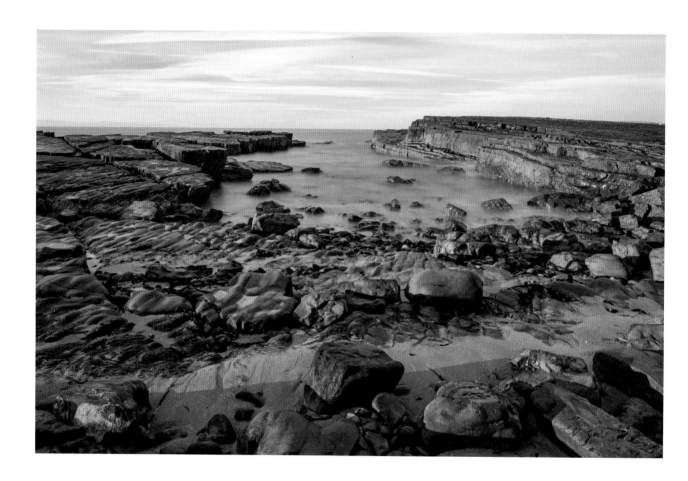

Previous page: Rock platforms at Kilbaha Bay, Co. Clare

Above: Kilbaha Bay, Co. Clare

Kilbaha, a village, containing 77 houses and 460 inhabitants. It is situated on the small bay of the same name, which is the first on entering the Shannon and forms an asylum harbour for fishing vessels and other small craft coming in from Loop Head.

From 'A topographical dictionary of Ireland', 1837

In the nineteenth century Protestant landlords suppressed the Catholic faith all over Ireland. In places, however, the Catholic Irish fought back, often by thinking – literally – out of the box. Marcus Keane, a land agent who lived in Kilbaha, built a Protestant church and a number of schools around the Loop Head Peninsula where the Protestant faith would be taught and, more importantly, free food would be provided to the children. After the famine years the latter was a huge incentive for many to renounce Catholicism.

The Catholic priest, Father Meehan, tried his best to fight back by building his own schools and a church. Without any land at his disposal, however, this was difficult. Father Meehan tried to hold mass in big, tent-like structures, as well as in his own home. The tent wasn't able to withstand the windy West Clare weather and after Marcus Keane heard of mass being held at Father Meehan's home, the priest got evicted.

It is said that after a visit to the beach in Kilkee Father Meehan came up with an inspired out of the box idea. At the time so called 'bathing machines' were used in Kilkee, small wooden rooms on wheels that acted as changing units. Father Meehan got a carpenter in Carrigaholt to build him a wooden box similar to the Bathing Machines.

The second part of Father Meehan's plan was based on that by law the intertidal zone was a no-man's-land where the Protestant landlords had no power.

Every week the Little Ark, as Father Meehan's wooden box begun to be called, was brought to Kilbaha Beach at low tide. The congregation, up to three hundred people, would kneel on the sand and mud while Father Meehan would say mass from his makeshift church. And there was nothing Marcus Keane could do about it.

Today the Little Ark rests in an annexe to the church in Kilbaha.

Overleaf top: Kilbaha Pier and Beach, Co. Clare
Overleaf bottom left: The Little Ark, Kilbaha, Co. Clare
Overleaf bottom right: The Reading Tower and Kilbaha Bay, Co. Clare

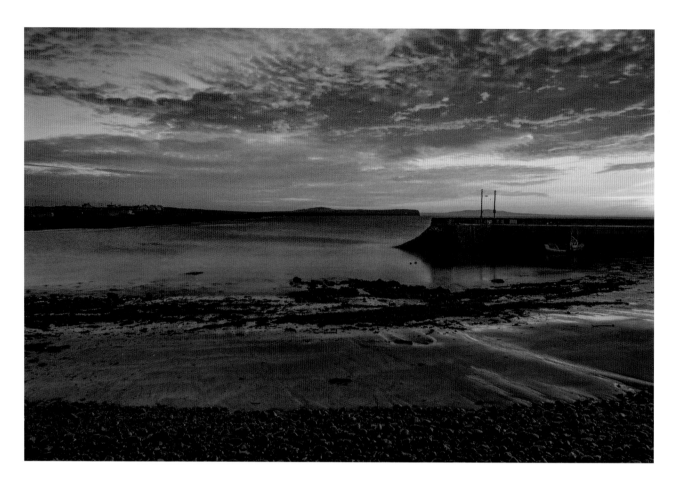

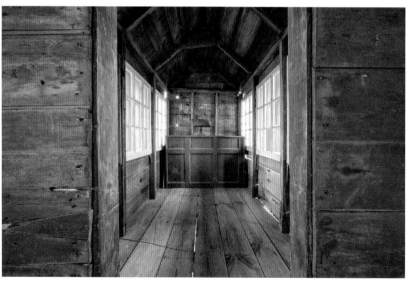

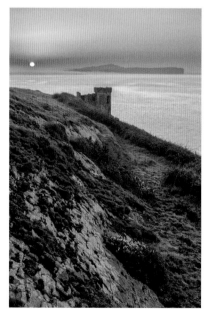

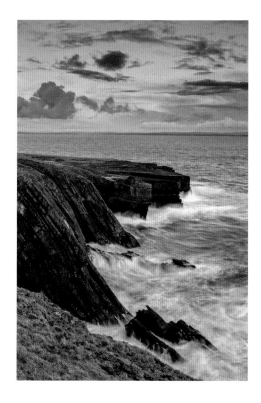

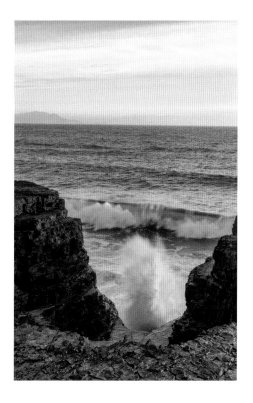

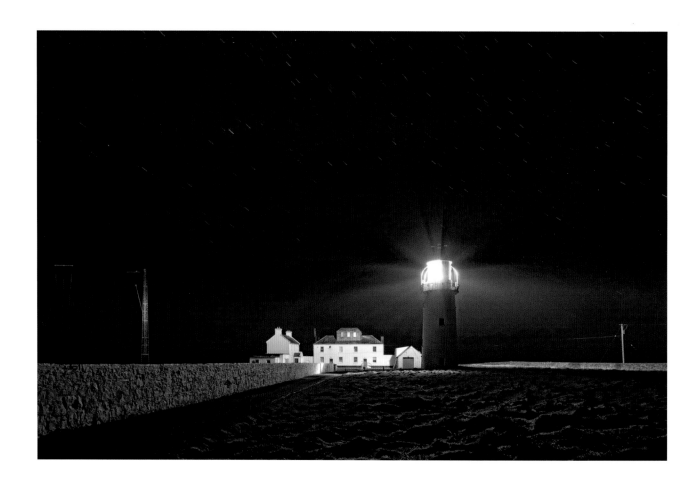

Previous page top: The Little Ark at the Church of the Little Ark, Kilbaha, Co. Clare

Previous page bottom left: Loop Head, looking east, Co. Clare

Previous page bottom right: Loop Head and the Mouth of the Shannon, Co. Clare

Above: Loop Head Lighthouse, Co. Clare